# BRAVE INTUITIVE PAINTING

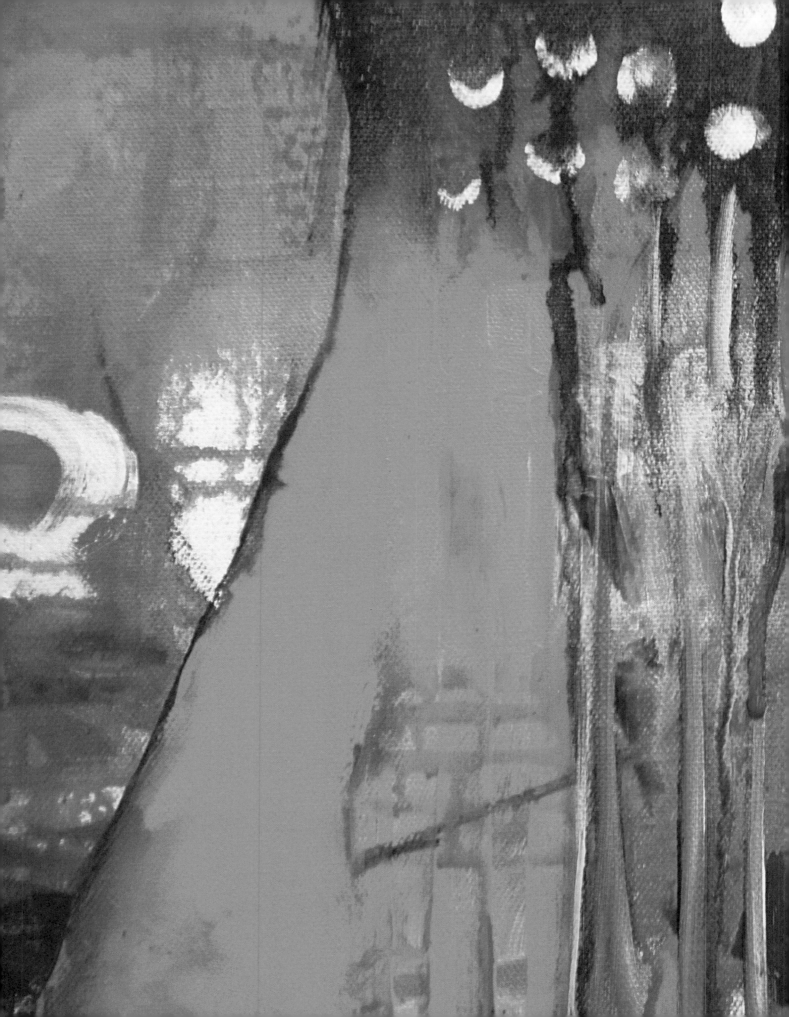

# BRAVE INTUITIVE PAINTING

Let go. Be bold. Unfold.

**FLORA BOWLEY**

**Quarry Books**
100 Cummings Center, Suite 406L
Beverly, MA 01915

quarrybooks.com • craftside.typepad.com

© 2012 by Quarry Books

First published in the United States of America in 2012 by
Quarry Books, a member of
Quayside Publishing Group
100 Cummings Center
Suite 406-L
Beverly, Massachusetts 01915-6101
Telephone: (978) 282-9590
Fax: (978) 283-2742
www.quarrybooks.com
Visit www.Craftside.Typepad.com for a behind-the-scenes peek
at our crafty world!

10 9 8 7 6 5 4 3 2 1

ISBN: 978-1-59253-768-6

Digital edition published in 2012
eISBN: 978-1-61058-391-6

**Library of Congress Cataloging-in-Publication Data**

Bowley, Flora S.
 Brave intuitive painting-let go, be bold, unfold! : techniques for
uncovering your own unique painting style / Flora S. Bowley.
    pages cm
 Summary: "Adopt a spontaneous, bold, and fearless approach to
painting as a process of discovery--one that results in lush and
colorful finished works that will beg to be displayed. This inspiring
and encouraging book for both novice and experienced painters
teaches how to create colorful, exciting, expressive paintings
through a variety of techniques, combining basic, practical painting
principles with innovative personal self-expression.  Flora S. Bowley's
fun and forgiving approach to painting is based on the notion that
"You don't begin with a preconceived painting in mind; you allow the
painting to unfold." Illustrating how to work in layers, Flora gives
you the freedom to cover up, re-start, wipe away, and change courses
many times along the way. Unexpected and unique compositions,
color combinations, and subject matter appear as you allow your
paintings to emerge in an organic, unplanned way while working from
a place of curiosity and letting go of fear"-- Provided by publisher.
 ISBN-13: 978-1-59253-768-6 (pbk.)
 ISBN-10: 1-59253-768-5 ()
 1. Painting--Technique. I. Title.
 ND1471.B69 2012
 751.4--dc23

                                        2011049714

Design: Rita Sowins / Sowins Design
All photography by Tara Morris with the exception of the following:
Helen Agarwal, 86; Stephen Funk/www.stephenfunkphotography.com,
46; 59; 80; 85; 114; 115 (bottom); 117; Tyson Robichaud, 128;
Shutterstock.com, 89; 92

Printed in Singapore

# CONTENTS

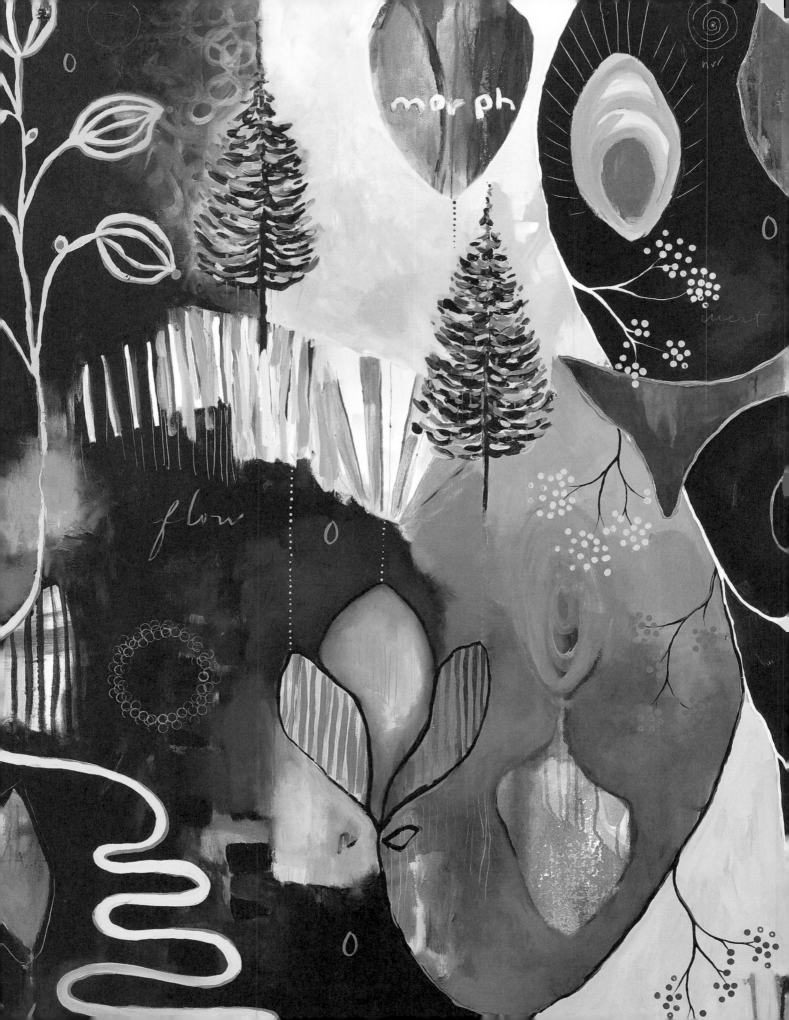

# INTRODUCTION

For many years I struggled with my desire to paint for the sake of exploration, raw expression, and release. I thought my art needed to support an intellectual theory, make a political statement, or in some way change the world. Eventually I surrendered, allowing myself to paint for the purpose of painting and the joy it brings.

After many years of following my heart, I now understand that the very act of pure expression does change the world.

It changes the world by changing each and every person who is brave enough to pick up a paintbrush, open themselves up to the unknown, and express themselves honestly and intuitively. It is through this kind of heartfelt expression that truths are revealed, lives transform, and new worlds are born.

# LET GO:
# OPENING UP TO A WORLD OF CREATIVITY WHERE ANYTHING IS POSSIBLE

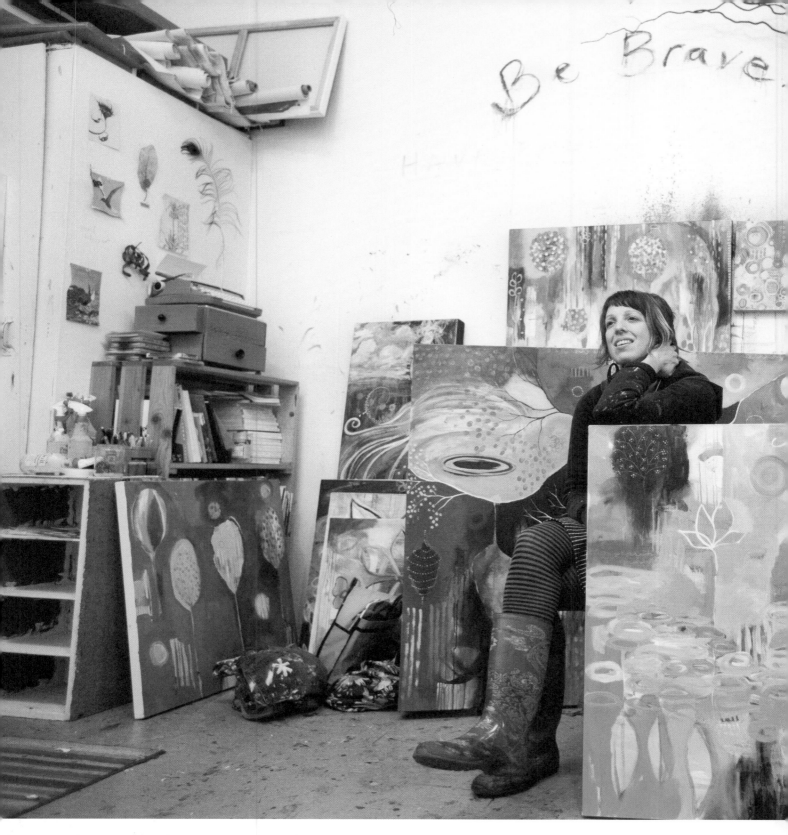

"The moment in between what you once were, and who
you are now becoming, is where the dance of
life really takes place." —BARBARA DE ANGELIS

# RE-CREATING YOUR STORY

Based on past life experiences, opinions we've been taught to accept as truths, and stories we've decided to believe along the way, we all go through life with different beliefs about who we are and what we are capable of doing in this lifetime. We may or may not consider ourselves to be creative, and calling ourselves artists may be an even greater stretch. I grew up with the belief that only a select group of special people could actually be artists, and surely I was not one of them. However, I kept following my deepest calling, and I continually found myself making art. Slowly and steadily my belief system about creativity and being an artist dramatically shifted. I now understand that human aliveness is inseparable from creativity. We are all artists already... each and every one of us.

## NOTICING

Human aliveness is inseparable from creativity. I believe that creativity and intuition are intimately connected. We were born with, and continue to possess, deep wells of inner wisdom and creative impulses just waiting to be listened to and acted on. The key to unlocking these inherent creative forces begins with letting go of the fear and negative stories that hold us back in order to make space for the new, positive stories to emerge.

The first step is to recognize what stories are creating your life right now. Notice what kind of self-talk is playing like a broken record in your mind. Do you tell yourself you are unable to let go creatively? Do you allow fear of failure to keep you from starting new projects altogether? Are you ready to soften this voice in your head, choose affirming thoughts, and step into a new way of approaching your work that is gentle, fun, and forgiving? If so, you have picked up the right book. There is a world of creative possibility waiting for you to embrace it.

Throughout this book, I've included prompts and reminders to support you in the process of connecting to your inner landscape and noticing what is true for you in the moment. These exercises are meant to realign, inspire, and make space for you to re-create your story however you choose. Remember, the world is in vital need of authenticity, integrity, connection, and self-expression, and creating art is a powerful way to feed this hunger and connect to your true self along the way. Art truly does save.

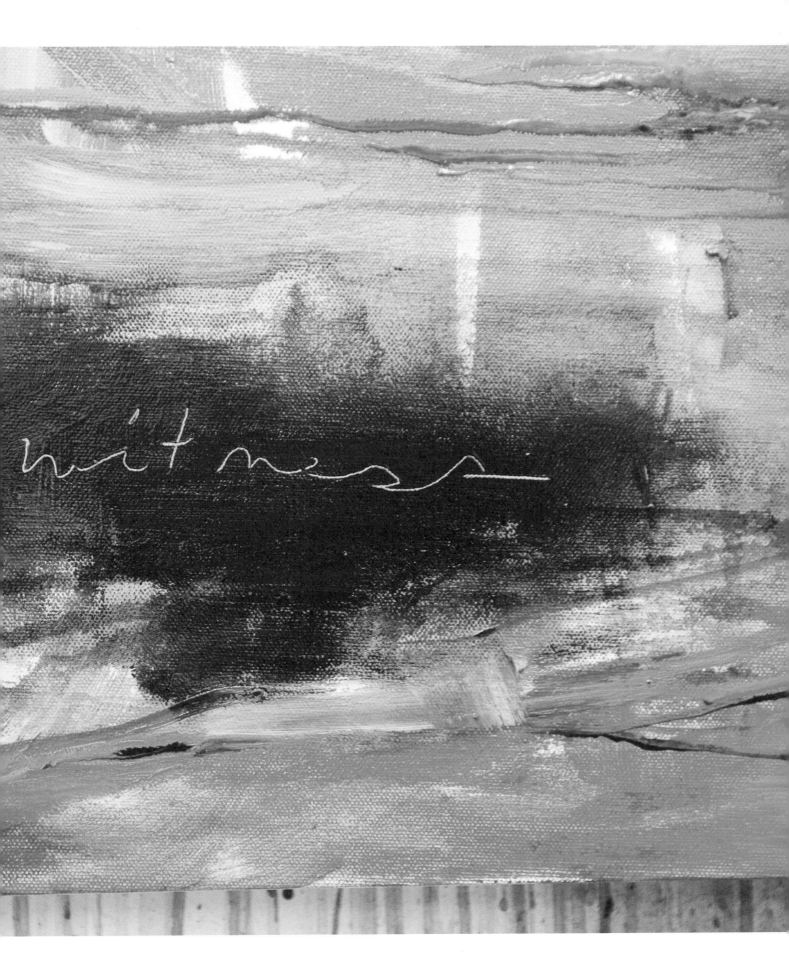

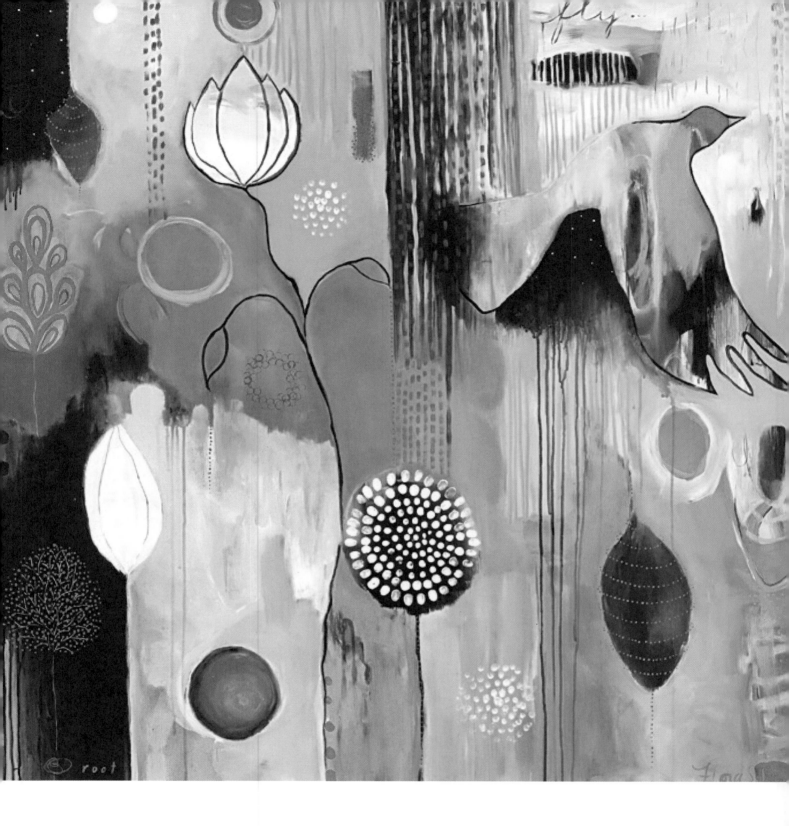

"By choosing your thoughts, and by selecting which emotional currents you will release and which you will reinforce, you determine the quality of your Light. You determine the effects that you will have on others and the nature of the experiences of your life." —GARY ZUKAV, THE SEAT OF THE SOUL

## CONNECT: CHANGE YOUR THOUGHTS. CHANGE YOUR LIFE.

Before you dive into the painting process, sit quietly with a journal. Notice what stories emerge in your mind as you consider your creativity. How do you respond to the questions "Are you creative?" and "Are you an artist?" Write your stories down honestly as they arise in your mind. Choose two or three stories to re-create into positive affirmations. For example, if your story is "I don't know how to paint," your new affirmation might be "I paint with joy and ease." You can transform "I don't know how to work with color" into "Painting with color is effortless and spontaneous." Write your new affirmations as if they are already happening instead of as goals to aspire to. Post them where you'll see them every day. Share your positive new declarations with your friends and speak them out loud often and with confidence. Changing how you talk to yourself and others has tremendous power to transform what feels possible in your life. Remember, you have the power to manifest whatever life you choose, so be specific about what you want.

As you tend to your new stories and grow into their truth, notice what other stories might still be holding you back. What do you tell yourself about creating abundance through your creativity? How do you feel about belonging to a creative community? If you notice any more limiting ways of thinking, create new affirmations around these blocks and begin again. This is a lifelong practice. There is no end point. There are simply layers to peel back and beautiful gems to uncover as you step into your most powerful and authentic self. Be patient, be gentle, and don't forget to notice all the simple treasures along the way.

# THERE
ARE NO
MISTAKES

Often the fear of not knowing what to do or the fear of doing something wrong stops us in our tracks and keeps us from starting. If we can let go of this fear, we open ourselves up to a much larger world of expression—a world where anything is possible. I strongly believe that there are no mistakes in the creative process. Everything that happens along the way—every dab of paint, every emotion that arises, every brave new choice—is an important ingredient in the final offering. Working from this perspective leaves no room for fear to slip in … there is no wrong way. There *are* no mistakes. There is only a wide-open canvas beckoning your artistic muse to come out and play.

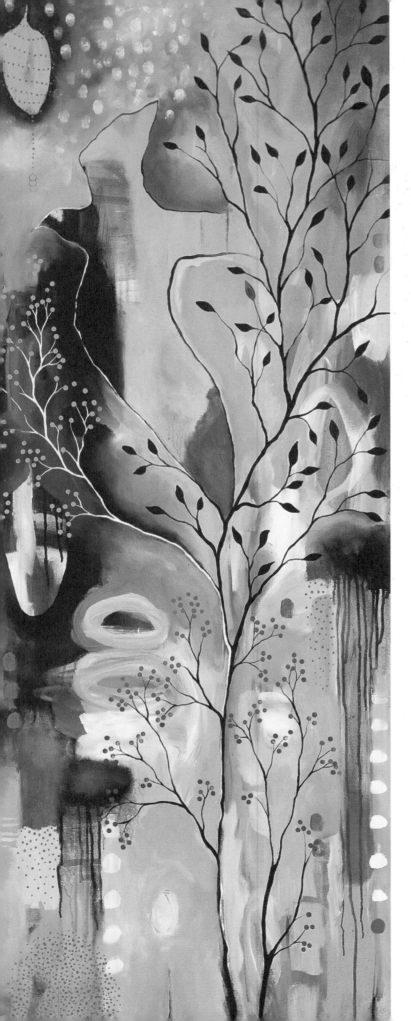

"We must be willing to let go of the life we planned, so as to have the life that is waiting for us." —JOSEPH CAMPBELL

## GETTING OUT OF YOUR OWN WAY

Working in layers with acrylic paint is incredibly forgiving and supports the belief that "there are no mistakes." It provides the freedom to cover up, restart, wipe away, and change courses many times along the way. In fact, changing your mind is actually an important and celebrated act in this process. It allows you to honor your intuition and the ever-changing present moment. This practice is playful and spontaneous, and it keeps the focus on the process of exploration and discovery … not on a preconceived idea of what the final paintings will look like. Often, paintings with the most layers turn out to be the most interesting, deep and complex creations in the end. Unexpected and unique compositions, color combinations, and subject matter appear when you move out of your own way and allow your paintings to emerge organically. Working from a place of open curiosity and recognizing that there are no mistakes will set your creative impulses free.

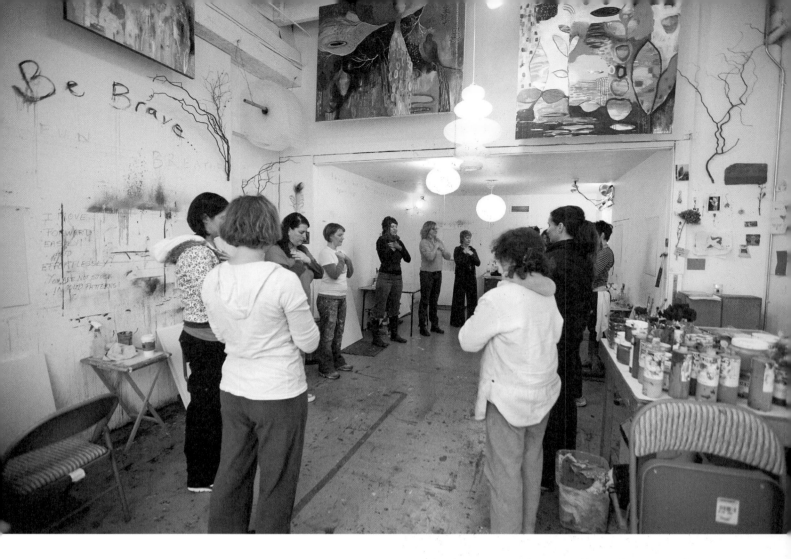

# CONNECTING WITH INTUITION

With so many thoughts running through your mind, how do you know which voice to listen to? How do you distinguish your intuitive guides from those well-trained logical voices telling you to make "good decisions" and "do the right thing"? Consider for a moment that your intuition is not always *loud*. Your inner wisdom is actually quite humble and quiet, and doesn't care about making sense. For

these reasons, you also need to become quiet to really hear what your wisest self already knows. Try to incorporate at least a few minutes of meditation into each day to connect with your breath and quiet your mind. This practice will create space for your intuitive guides to emerge and be heard. Remember, the more time you cultivate for stillness, the sharper your intuition will become.

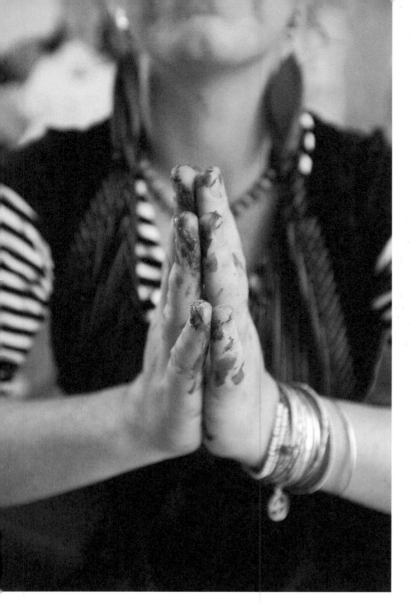

"Cease trying to work everything out with your minds. It will get you nowhere. Live by intuition and inspiration and let your whole life be revelation."

—EILEEN CADDY

## FOLLOWING YOUR HEART

Painting from a place of clear connection with your intuition allows you to create freely and without the constriction caused by fear and doubt. Your intuitive self is able to paint with spontaneity, passion, and courage—trusting in the unknown and believing everything you do is meant to happen. Instead of waiting for your thoughts to dictate your actions, allow your creative impulses to lead the way. Are you inspired to paint with your hands? Do it.

Do you have an impulsive desire to turn your canvas upside down? By all means, turn it. Contrary to what we are so often told, there is no need for reasoning here. It is more important to listen *deeply,* trust *completely,* and respond *fully.* By honoring your inner wisdom, you connect to your true self and strengthen your intuition. This loop, in turn, feeds on itself in a beautiful way. TRUST. ACCEPT. ACT. ACKNOWLEDGE. REPEAT.

"The intuitive mind is a sacred gift and the rational mind is a faithful servant. We have created a society that honors the servant and has forgotten the gift." —ALBERT EINSTEIN

## CONNECT: YOUR BODY KNOWS BEST

To hone your intuition, notice the moments in your daily life when you are faced with decisions. They may be small choices, such as which street to turn down, or big decisions, like which job to accept. Allow yourself to pause before making these decisions. Close your eyes and move your awareness out of your thinking mind and into your whole body. Take a deep breath. What is your body telling you to do? Listen closely. Do you feel a pull in one direction? Do you feel a new sensation in your belly, your heart, or your throat? You may find that placing one hand over your heart and one hand over your belly helps you to tune in even more deeply. Follow these intuitive urges and notice where they take you. This path will likely lead you to a world of synchronicities and magical moments.

# KEEP IT MOVIN'

My approach to painting honors the connection I feel between my mind, body, and spirit. These aspects are inseparable and must all be activated in order to support the creative flow. As a child, my favorite activities were climbing trees, swimming, jumping on trampolines, and doing gymnastics. These activities brought me joy and made my soul feel alive. Today I understand how movement is a key ingredient in my creative process. It not only makes me feel good, but it directly supports my ability to open up, energize, and channel creative energy through my body and into my artwork.

Without a way to release it, holding tension in your body can lead to tension in your mind, such as the fear of doing something "wrong" or general frustration. Physical tension can also find its way into your brushstrokes. To keep your energy moving, take breaks while you paint. If you are able, get your body and breath in motion. Often. A quick walk around the block or a thirty-second dance party has the power to re-energize your body and give you a fresh perspective on your work. Find ways to move your body that are fun and feel good for *you* ... this is the best way to keep you coming back for more. I've included simple exercises and suggestions throughout this book to help you "Keep It Movin'." Here's one to get you started ...

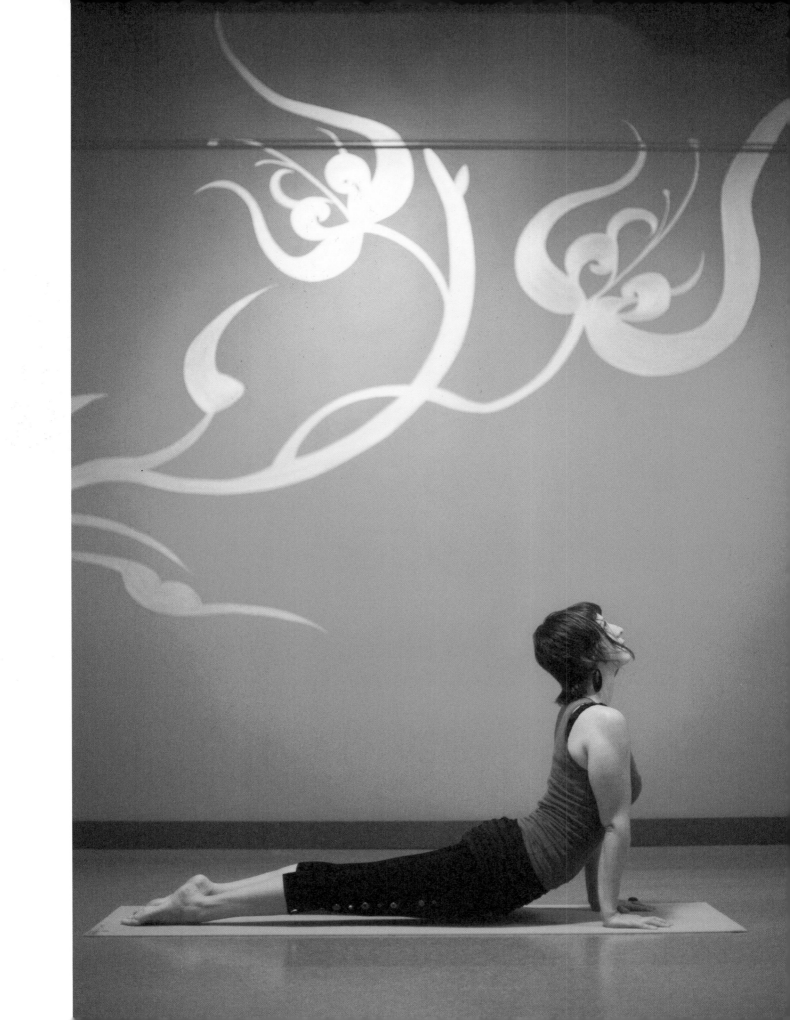

## KEEP IT MOVIN': DANCE LIKE NO ONE IS WATCHING!

Play a song you love. Hold a paintbrush loosely in each hand. Keep your knees bent and stay relaxed in your shoulders, elbows, and wrists. Slowly start to sway. Let the music guide your movements as you shift your weight back and forth between your feet. Close your eyes and start to incorporate the rest of your body. Don't forget to move your hips and your head. Feel the fluidity in your body. Notice if you start to clutch the brushes or areas of your body, such as your face, throat, belly, or upper back. Imagine you have a large canvas in front of you.

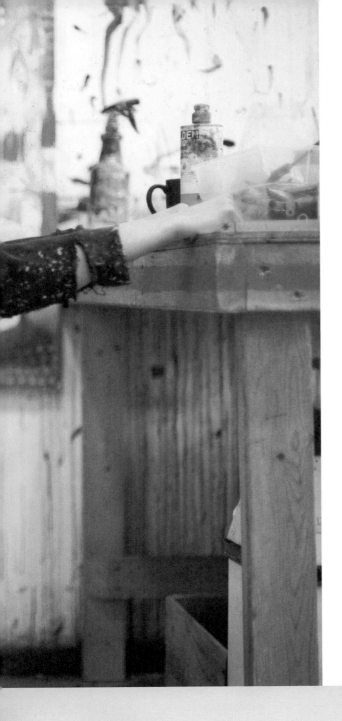

"Work like you don't need the money. Dance like no one is watching. Sing like no one is listening. Love like you've never been hurt. Live life every day as if it were your last."

—IRISH PROVERB

Allow the music and your breath to guide your movements as you "paint" large, sweeping strokes across your imaginary canvas. Let your movements originate from the center of your body. As you move, reach your arms far into space, beyond your typical range of motion. When you are ready, add some paint to your brushes and repeat with a canvas in front of you. Enjoy all the ways your body can move, and watch as your canvas comes to life with colorful gestures.

# STEPPING
# FEARLESSLY
# INTO THE
# UNKNOWN

This painting process is about allowing your art to unfold naturally, on its own time, and in delightful ways you can't even imagine before you start. It's tempting, and very natural, to want to know what your paintings are going to look like before they are finished, but the truth is you never really know what the future holds. Incredible amounts of energy are wasted by chasing what you cannot catch. Let go of the chase and embrace the unknown. By releasing the need to control the future, you open yourself up to the magic of the moment where everything is possible.

To support your journey into the unknown and encourage you to make space for the unexpected, I've included prompts and suggestions throughout this book. Here's a "Be Brave Challenge" to get you started on your journey into uncharted territory.

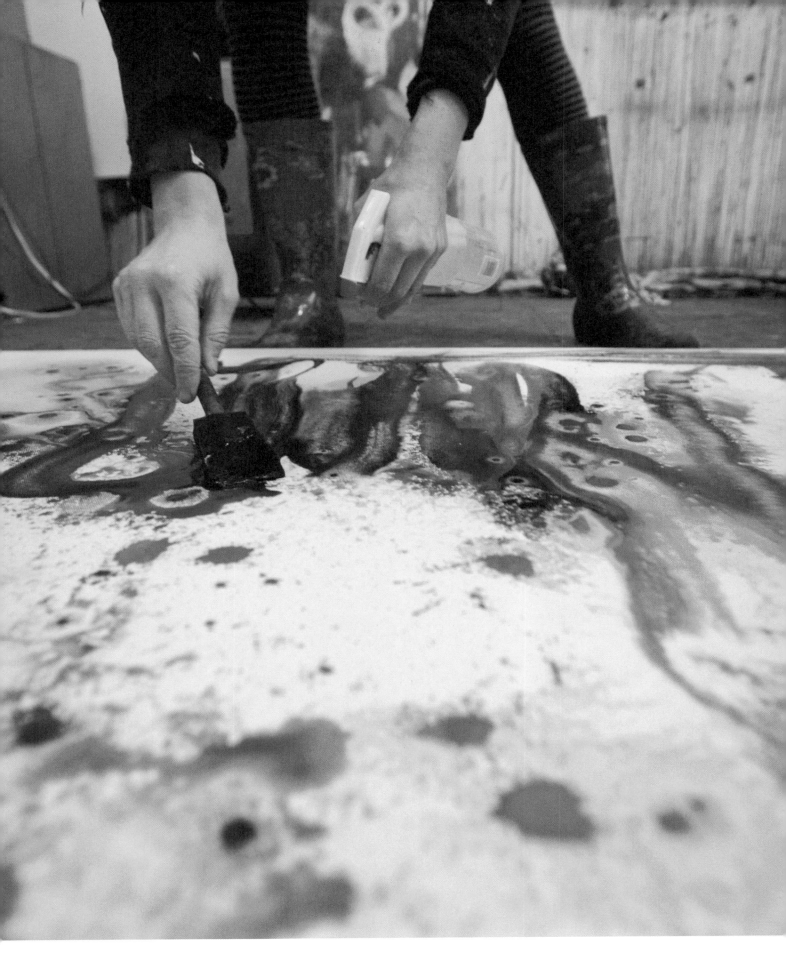

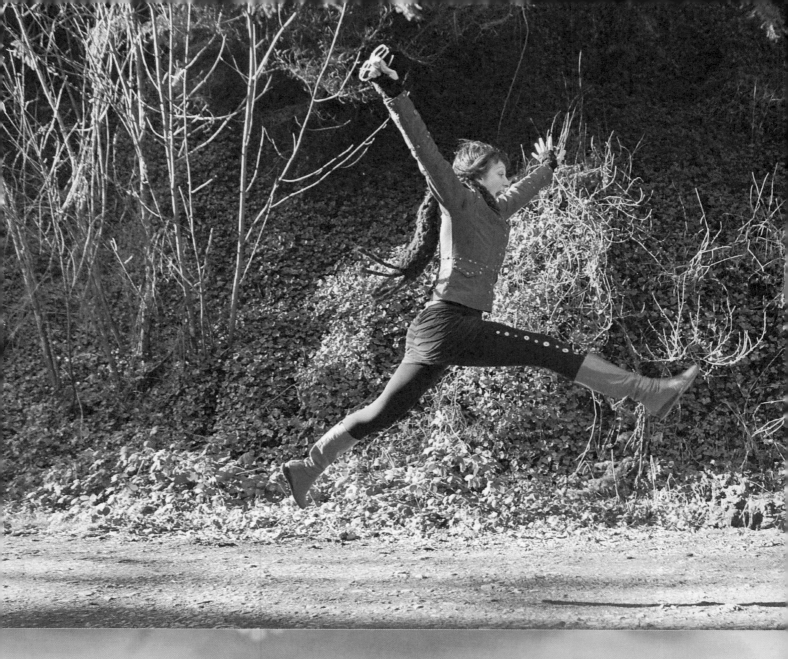

## BE BRAVE CHALLENGE: FEARLESS LIVING

Opportunities to face fears and embrace the unknown abound in our daily lives. When you listen and respond to your inner voice, even when it's daunting, you will move in new directions, connect with others, and exist in a world of possibility. Are you compelled to talk to a stranger? Are you drawn to explore a new culture? Do you have unrealized passions? Do you resist these urges because they are too scary, too crazy, or too uncertain? Consider that by honoring and following these urges, you are saying yes to something larger than your rational mind while nudging yourself gently toward more opportunity. The next time you have an urge to do something, respect your intuition and take action. Be brave and don't look back.

"Leap, and the net will appear."

—JOHN BURROUGHS

"Only those who will risk going too far
can possibly find out how far one can go." —T. S. ELIOT

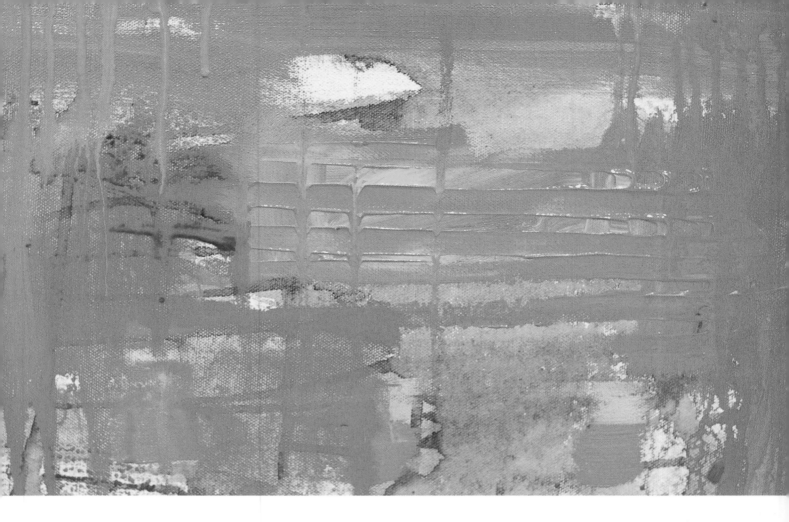

# LETTING GO
# OF PERFECTION

We all have different notions of perfection. Our ideas of perfection may come from our parents, the media, certain types of schooling, or pressures we put on ourselves. I encourage you to examine what your personal definition of perfection looks like. Can you loosen your grip on these ideas and make room for other variations of "perfect" to exist? Can you start to accept that whatever authentically emerges from you through your brave, intuitive process is perfectly perfect already?

Often the quest for perfection leads to the death of spontaneity, flow, and happy accidents. Rather than striving for a "perfect" image, embrace your own authentic journey in all its many stages. Be messy. Be brave. Show your brushstrokes and the emotions behind them. Resist the urge to paint "pretty" or "perfect" or "easy" and free yourself from these limiting ways of expression. Focus instead on staying present with your intuition in order to follow your heart. In doing so, you are offering your truest self to the world, and who knows, you may just stumble—raw and messy—into your next great breakthrough.

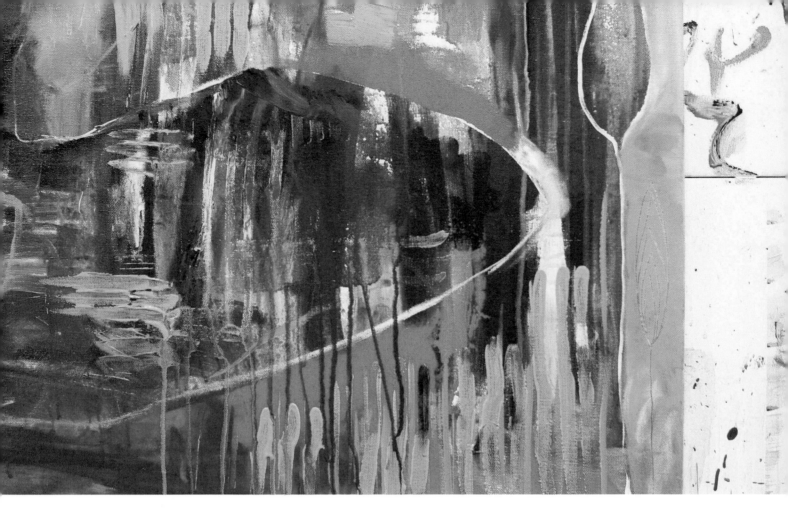

## BE BRAVE CHALLENGE: A NEW KIND OF PERFECT

Do you have an urge to paint something that perhaps scares you or makes you nervous? Is there something you keep buried inside that is yearning to leap out? This is your chance to release it! Start this challenge by choosing colors you don't typically work with. Work on a large sheet of paper or canvas … the bigger the better. Let go of your need to paint something pleasing or beautiful. Nobody needs to see this but you. Paint quickly and passionately. Explore. Be daring. When you are done, write the word *perfect* over the top of your new creation.

# BEING GENTLE WITH YOURSELF
## (AND OTHERS)

There are plenty of opportunities in our lives to strive, push, compare, compete, and struggle. For me, painting serves the opposite purpose. It is my time for self-reflection, patience, and healing. By diving deep into my own creative journey, I am able to see parts of myself that are kept hidden in my everyday life. The blank canvas gives these deeper emotions a space to reveal themselves in a nonverbal way. The canvas has no opinions. It will simply hold your offerings and reflect them back to you, clearly and without judgment. It is up to you to interpret and learn from what you have created. Color, form, and line express a language beyond the confines of words, allowing you to tap into a deep well of wisdom patiently waiting to be uncovered.

Also consider that time spent dedicated to your creativity equals time spent dedicated to creating a more whole version of yourself. It is through the process of listening to your intuition and responding in a fully expressive way that we discover and return to our most authentic selves. This is a gift not only for you, but for those around you.

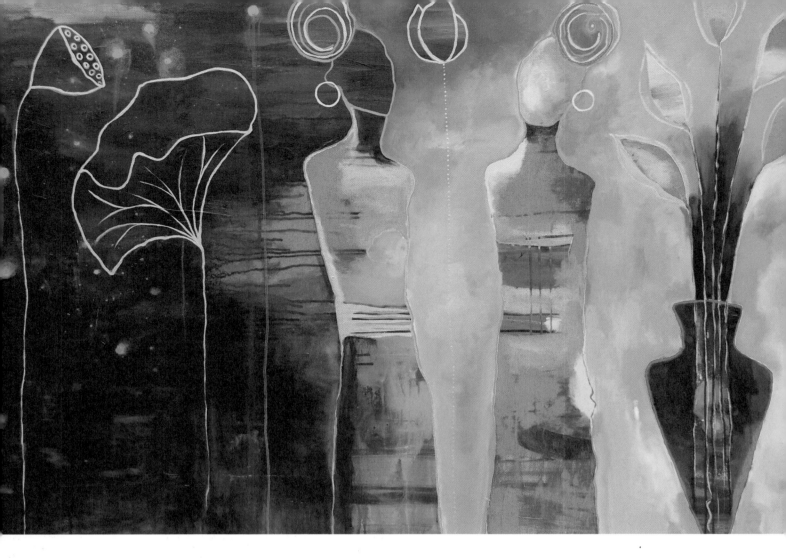

## YOUR GROWING EDGE

As forgiving as the process is, it does not mean your art-making journey will always be smooth and easy. Undoubtedly there will be many times in the creative process when you bump up against a wall, get pushed out of your comfort zone, or simply feel stuck. These uncomfortable moments are an absolutely natural and important part of the creative journey. When you hit these so-called walls, you are forced to either evolve or retract. I call this place your growing edge. It's not always a comfortable place to be, but it is a potent and vital part of your growth as an artist. Embrace these challenging moments as opportunities to step back, reevaluate, and grow in new directions—directions you never could have imagined before you got stuck. Be gentle with yourself and know that each and every time you feel frustrated or overwhelmed, you are in the perfect position to have a breakthrough. By moving through these difficult moments, you create new layers of depth in your painting and in yourself. Trust your intuition, stay focused on the journey, and allow your paintings to reveal themselves only when they are ready.

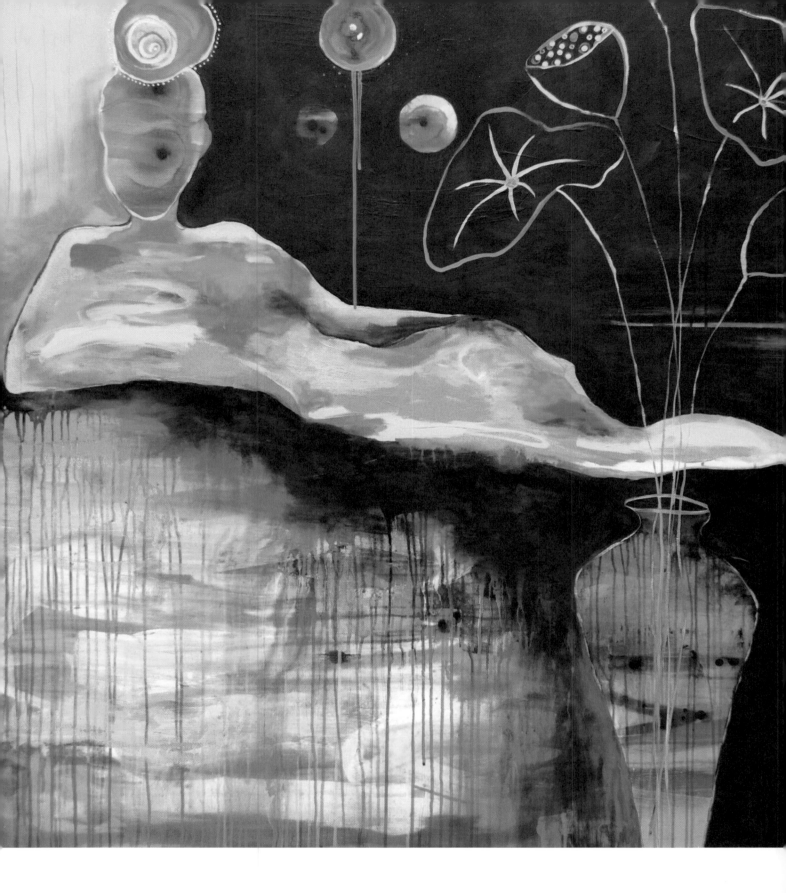

*"Be gentle with yourself.
You are a child of the universe
no less than the trees and the stars;
you have a right to be here.
And whether or not it is clear to you,
no doubt the universe is unfolding as it should."*

—MAX EHRMANN

## CONNECT: A CREATIVE DATE

Give yourself the gift of a healing, creative date with yourself. Set aside an entire evening to pamper, relax, and make art. Turn off your computer and gather your favorite art supplies. Play some relaxing music and indulge in a session of simple feel-good stretching. Take a few minutes to sit quietly and breathe deeply. Eat a delicious meal and slowly savor every bite. Go on a slow walk and open up your senses to the world around you. Remember, you are not in a rush. There is nowhere to *go* and nothing to *do*. After your walk, move into your creative space. Start with simple drawing. Allow your marks and lines to flow effortlessly. Don't worry about the finished "product." Consider this a massage for your creative spirit. Take breaks to dance, stretch, or write. End your date with a long, candle-lit bath. Ahhhhh ... you deserve to feel good.

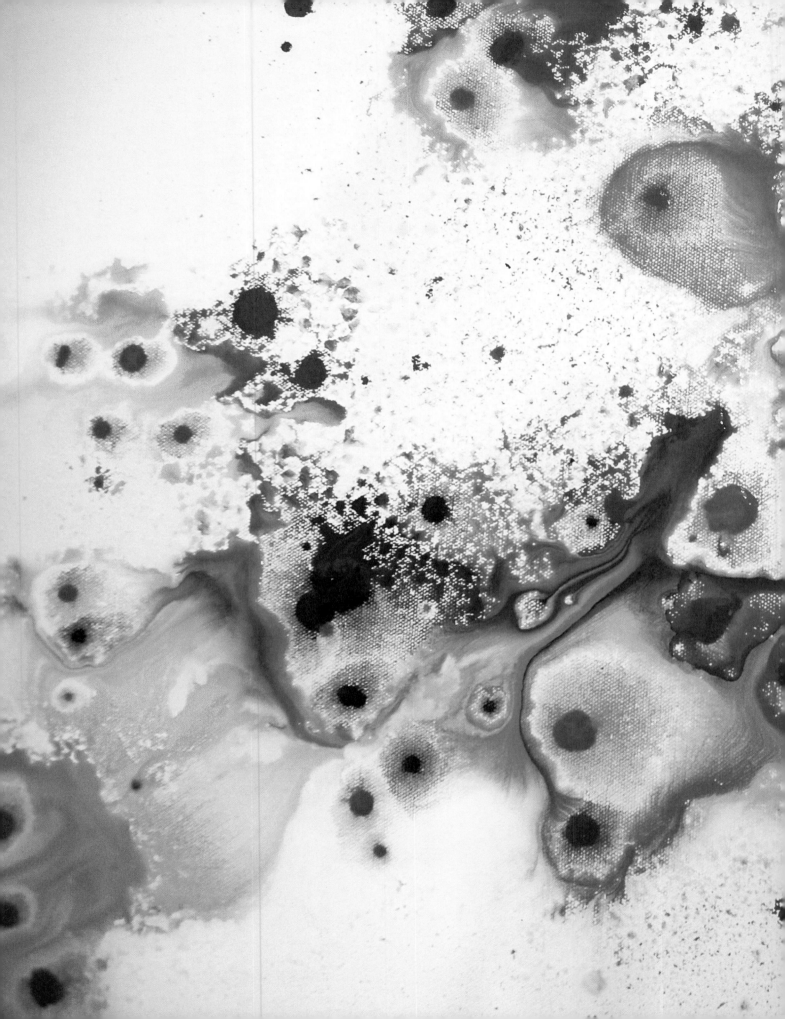

# BE BOLD:
## WORKING WITH WILD ABANDON AND COMMITTING TO YOUR ALIVENESS

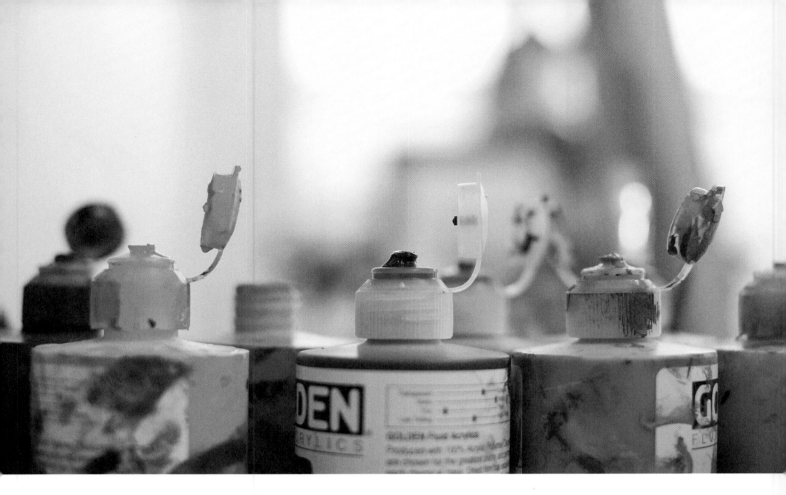

# TOOLS AND PROMPTS

To begin your brave, intuitive painting journey with the techniques shown in this book, you will want to have some basic tools on hand: a surface to paint on (canvas, paper, or panel), acrylic paint, a palette, foam brushes, small bristle brushes, your fingers, rags, "etchers," "stampers," and a spray bottle. I'll provide many prompts for each tool presented here, but keep in mind that this is just a starting point; there is no formula. Look around your house, your yard, and your community with an open mind. What else can you use as a painting tool, and how many different ways can you use this tool? Continuing to add tools and techniques to your repertoire will allow you to find and express your unique painting style with more of your own personal flair.

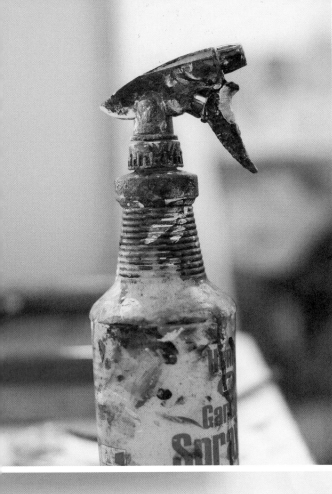

 **BASIC TOOL LIST**

- Canvas, paper, or panel
- Acrylic paint
- Palette
- Foam brushes
- Small bristle brushes
- Fingers
- Rags
- Etchers
- Stampers
- Spray bottles

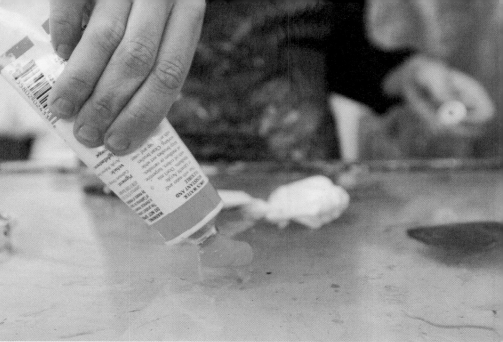

## SURFACES

I usually paint on canvas, paper, or panel, but stay open to other surface options that might come your way. Canvases can be purchased prestretched and preprimed or in rolls. You'll need to learn to stretch your own canvas if you choose to work on loose canvas—it's easy, so don't be daunted by the task. If you work on paper, find paper that is heavy enough to hold paint without warping. A 300-lb paper will work well. Panels can be made out of any wood (cherry, pine, bamboo, and maple are some common varieties) or pressed wood such as masonite. Each surface will offer different textures and flexibilities. I encourage you to experiment with different surfaces to find the ones you like the most.

You will find that choosing a large surface for this process will give you more space to loosen up and be bold. Start with a surface that is at least 30" x 30" (76 x 76 cm). You can always go bigger from there.

## ACRYLIC PAINT

If you've ever gone to an art supply store and looked in the acrylic paint section, you know there are many choices. The best way to find out what you like is to experiment with many different brands, colors, and fluidities. I tend to use Golden brand paint because I love the vibrancy of color and variety of fluidity. Golden makes both *heavy-bodied* paint and *fluid* paint. I use both in my work for various effects. The heavy-bodied paints are opaque and create a wonderful thick, buttery texture, whereas the fluids allow for beautiful transparent layers and washes. Experiment with both and find out what works for you.

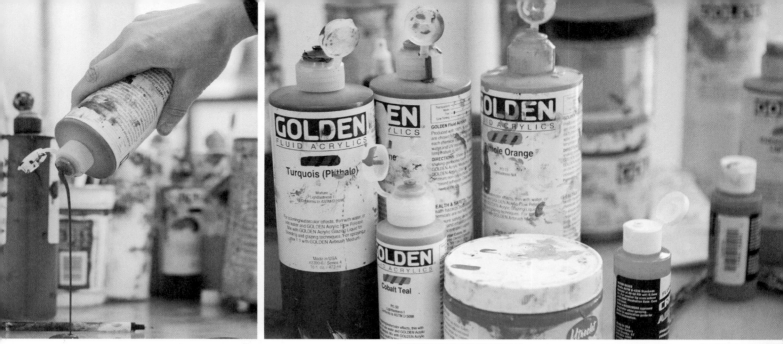

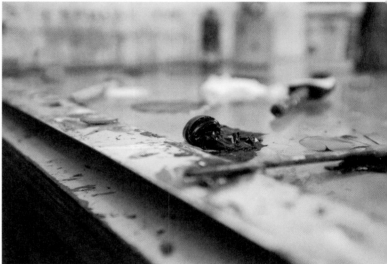

## PALETTE

A palette refers to the surface you put your paints on while you are working. Don't confuse this kind of palette with a color palette, which refers to a color scheme. My favorite type of palette to work from is a large piece of glass. Currently my palette is about 36" x 36" (91 x 91 cm), so I have plenty of space for many colors without worrying about the colors mixing together accidentally. I often use old windows or any old piece of glass I can find and reuse. If the edges are sharp, cover them with tape. Place a bright white piece of paper beneath the glass so you can see your colors in their truest form. At the end of your painting session, use up as much paint as you can (this is a great time to start the first layer of your canvas) and leave the rest to dry. The next time you paint, simply spray water onto your glass palette, and scrape it off with a razor blade. You can use your glass palette for years and years. If you don't have glass, old cookie sheets or muffin tins are fine alternatives.

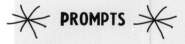

## ✳ PROMPTS ✳

- Drag the wide side of your foam brush across the canvas.
- Drag the corner of the brush across your canvas.
- "Skip" the brush down your canvas to make a series of marks in a pattern.
- Twirl the brush in your hand as you drag it across your canvas.
- Twirl the brush while holding it in one place on your canvas.
- Add two different colors on each corner of the brush and blend these colors directly on your canvas.
- "Scrub" the foam brush around your canvas in a variety of sporadic directions.
- Stamp different parts of the brush on your canvas to make a variety of marks.
- Look around the room and loosely draw something you see with your foam brush. Don't worry about what it looks like.
- Use the wooden-handled end of the brush to make circular stamps.
- Come up with your own way of making marks with your foam brush.

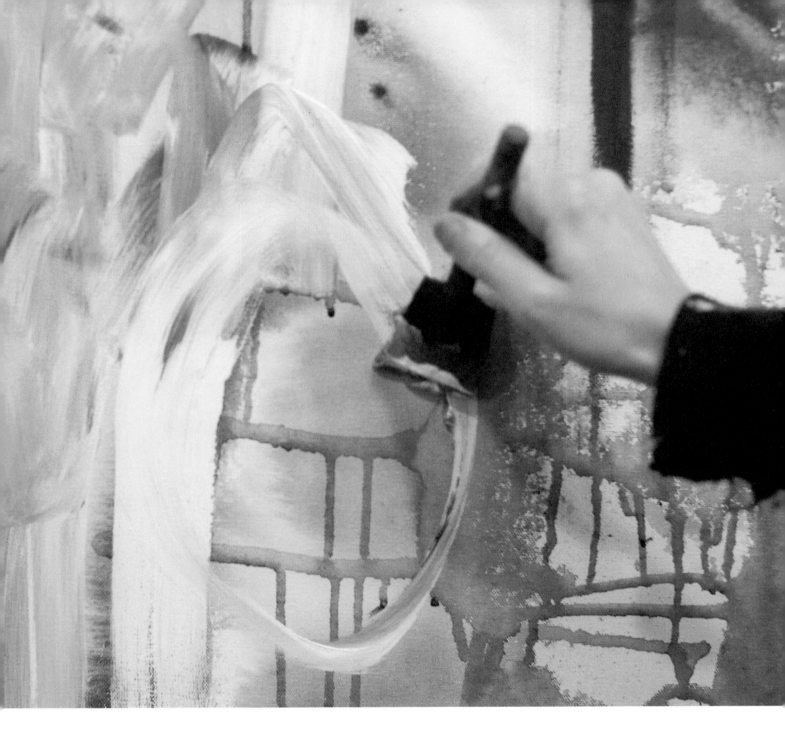

## FOAM BRUSHES

Cheap foam brushes from the hardware store are handy and can create some great effects. I originally started using them when I couldn't afford anything else, but over the years, they have become my favorite type of brush. I enjoy the wide versatility of their mark and their ability to soak up lots of paint. The key to using them in a painterly way is to hold them loosely and get comfortable spinning the handle around in your hand. This will allow for many types of marks and color fields to be created with the foam brush. I find the stiffer version of these brushes works the best.

## SMALL BRISTLE BRUSHES

Smaller brushes are good for adding details into a painting. I use these brushes when I want to draw on the canvas to create new compositions. I also use small brushes to incorporate words and other fine lines. I love the juxtaposition of adding fine detail over large swaths of colors. These delicate details can quickly breathe new energy into your painting. It's also important to give your marks character by using both thick and thin lines. This kind of diverse line quality mirrors the natural world more accurately and brings your lines to life.

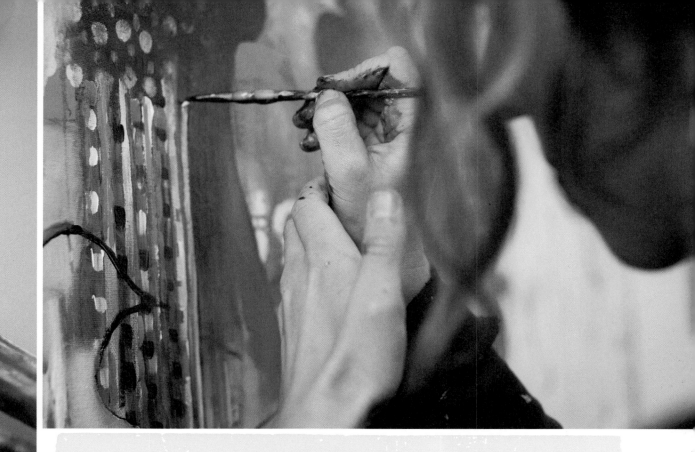

## ✳ PROMPTS ✳

- Hold the brush loosely and drag it across your canvas while twirling it in your hand to release the paint slowly off the end of the brush.

- Create variation in your line quality by pushing the brush down harder to widen your line and ease up on your pressure to thin the line out.

- Play with creating thick and thin marks in one continuous line.

- "Skip" the brush across your canvas to make smaller hash marks.

- Write the first word that comes into your mind.

- Make quick, sporadic marks.

- Draw something that you see around you, such as a plant, a figure, a light fixture, or some items on your table.

- Draw circles, big and small, allowing them to extend off the edges of your canvas.

- Experiment with the emotion behind your marks: For example, create marks that are dainty, bold, passionate, timid, frenzied, wild, subtle, and so on.

- Use the opposite end of your brush to scrape into wet paint.

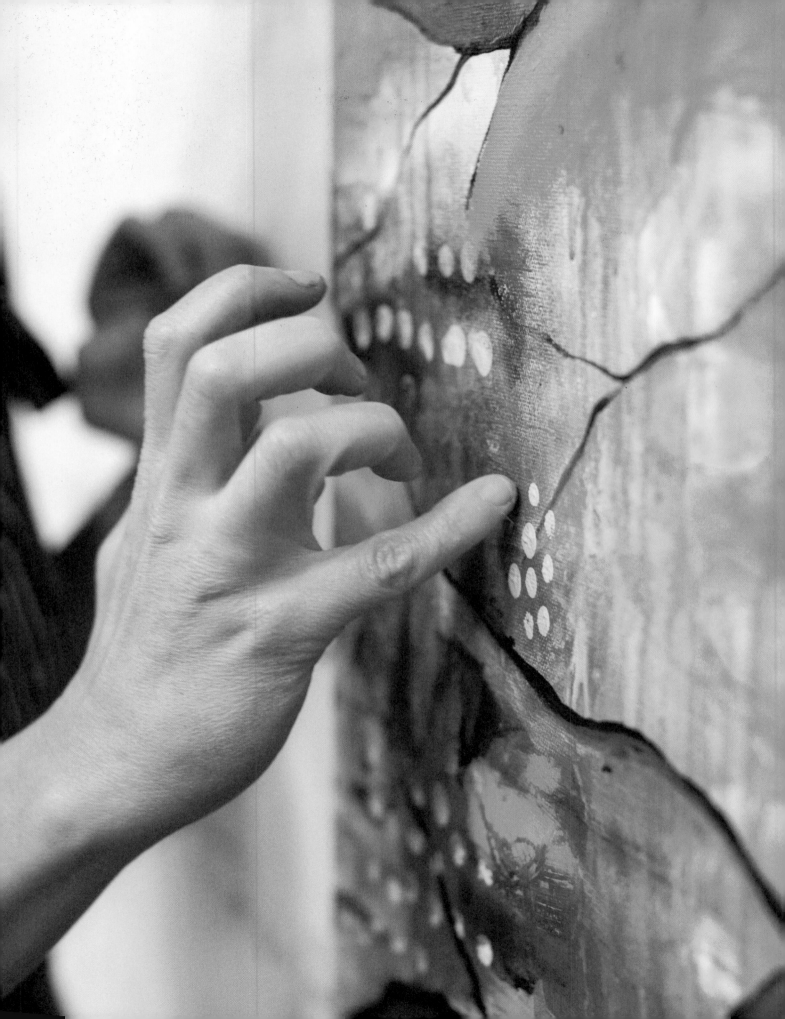

## FINGERS

Kids naturally paint with their fingers, and I also love the experience of feeling the paint on my hands rather than separating myself from the paint with a brush. There is an intimacy and a subtlety that only the fingers can offer, and the variety of marks made by your fingers is infinite. I use my fingers as frequently as I use my brushes—if not more. Remember, there are many ways to experiment by using your fingers. Find your own playful ways of working with your hands … ways that feel good to you and create your own signature marks. As you experiment, try using your nondominant hand. This is a great way of letting go and getting out of your head. Note: Wear plastic gloves or a barrier cream if you want to protect your skin.

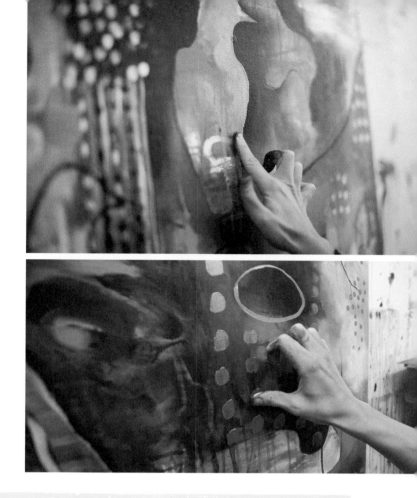

## ✳ PROMPTS ✳

- Dab a bit of paint on the very end of your pinkie finger to create very small dots. Use your pointer finger to make bigger ovals.
- Use the side of your thumb to create larger marks.
- Dab paint onto all of your fingers and simultaneously drag them down the canvas to create parallel lines.
- Dab paint onto all your fingertips and apply the paint like rain falling onto your canvas.
- Smear or "feather" wet paint with your fingers.
- Draw something with your fingers.
- Drag your fingers through an area of thick paint to remove the paint and wipe the paint you picked up somewhere else on your canvas.
- "Dance" your paint-covered fingers across the canvas while listening to music.
- Imagine playing the piano as you make marks with your fingers across your canvas.
- Experiment with your own personal style of finger painting. Have fun!

## RAGS

Rags are not just for cleaning. I use rags to wipe off paint, blend edges, and add texture. You'll find that acrylic paint is very forgiving and wipes away easily. As long as the paint is still wet, you have the option of wiping it all or partially away. You may choose to purposefully remove specific parts to reveal interesting areas beneath or you may want to wipe away and boldly rework an entire section. Be playful with how you use rags … your options are endless.

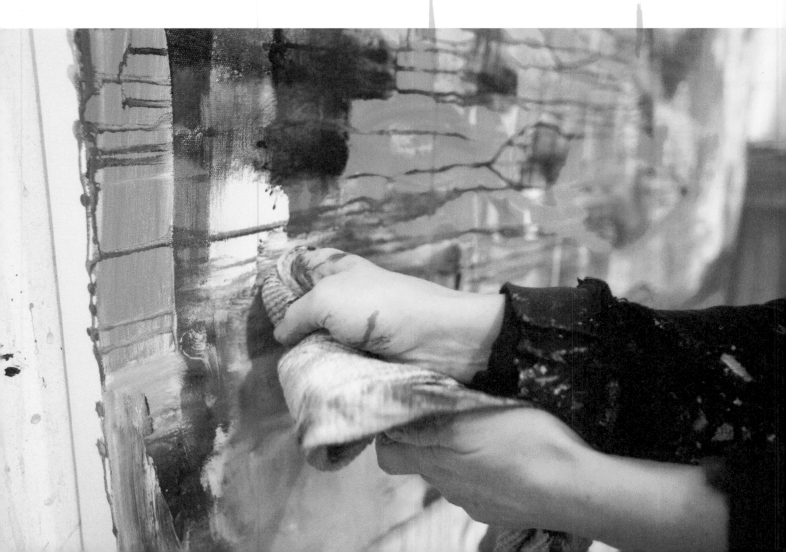

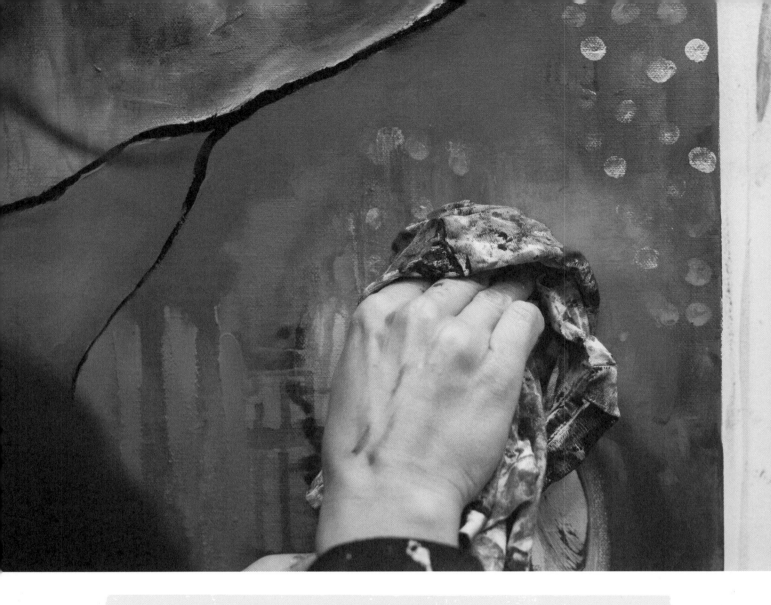

## ✳ PROMPTS ✳

- Wrap the rag around your pointer finger and drag this finger through wet paint to reveal the color underneath.

- Add wet paint to your canvas with a rag.

- Bunch up your rag and drag it through large areas of wet paint.

- Spray water onto wet paint and then drag your rag through this area.

- Create texture with your rag.

- Draw an image or pattern by removing paint with your rag.

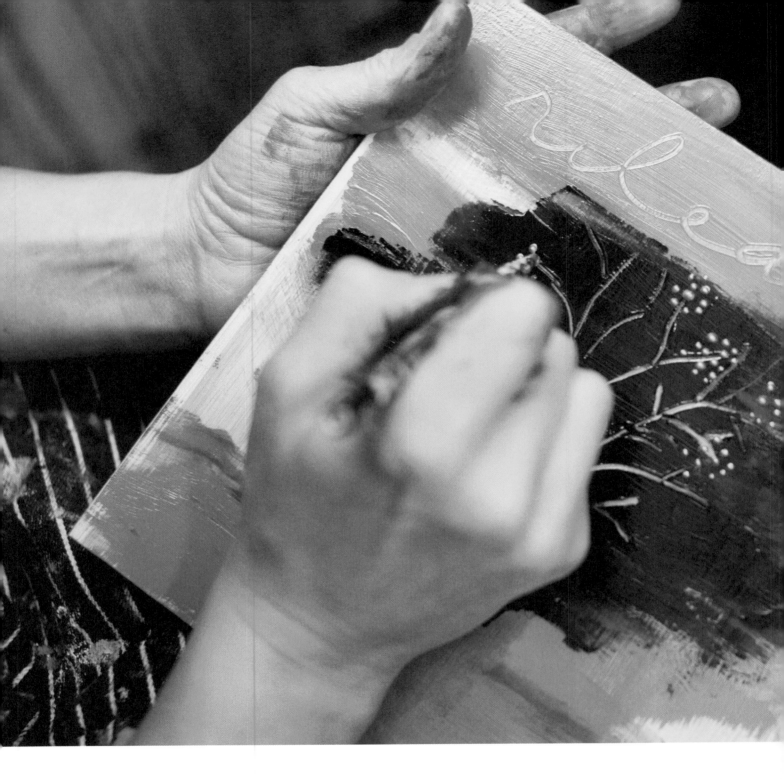

## ETCHERS

Etching through wet paint to reveal the colors beneath can be done with any kind of sharp object. I often use old nonworking pens or pencils. Look around your world and be creative. Etching into wet paint is a great way to add an element of fine detail or drawing into your painting. Keep in mind that if the paint is still wet, the etching can be wiped away if you change your mind. This is a forgiving process, so play with it and have fun.

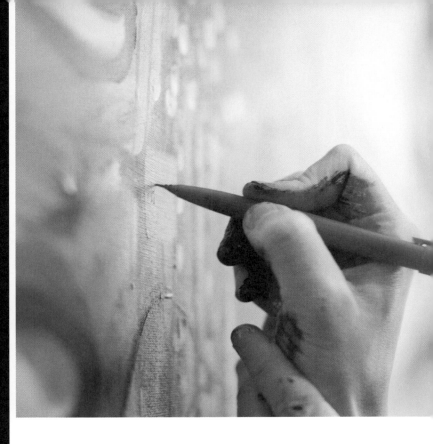

## ☀ PROMPTS ☀

- Using the sharp end of the pen or any other pointy object, drag the tip through a wet area of paint to reveal the color underneath. Be careful not to poke a hole through the canvas.

- Add red paint over an area of dry green paint, and etch into the wet red paint. Notice how the contrasting complementary colors look together.

- Try this with other complementary colors such as blue and orange or yellow and violet.

- Etch a word.

- Etch a pattern of lines.

- Etch tiny shapes.

- Etch an image you see in the room.

- Etch another image, then wipe half of it away.

- Try etching with a new object.

## STAMPERS

There are no limits to what you can use to lift the paint from your palette and stamp it onto your canvas. I've seen students stamp with toy cars, paper towel tubes, doilies, feathers, bubble wrap, and various utensils. I personally love old film canisters and pen caps to create stamped-on circles. Get creative. Look around your house, your studio, or outside for objects with interesting textures, shapes, or moving parts. You might just stumble on your signature mark-making device!

A note on stamping: It will be much easier for you to stamp if you use fluid paint. It will flow effortlessly off your "stamper" as opposed to the blobs you might fight against with heavier-bodied paint.

## ✳ PROMPTS ✳

- Dip an object into fluid paint, then press it onto your canvas.
- Keep stamping with the same object until all the paint comes off your stamper. Notice how your marks change as the paint wears thin.
- Stamp a pattern.
- Stamp quickly and chaotically.
- Stamp slowly and methodically.
- Find a new object to use as a stamper.
- Layer different kinds of stamped images on top of each other.
- Drag your stamper across your canvas.

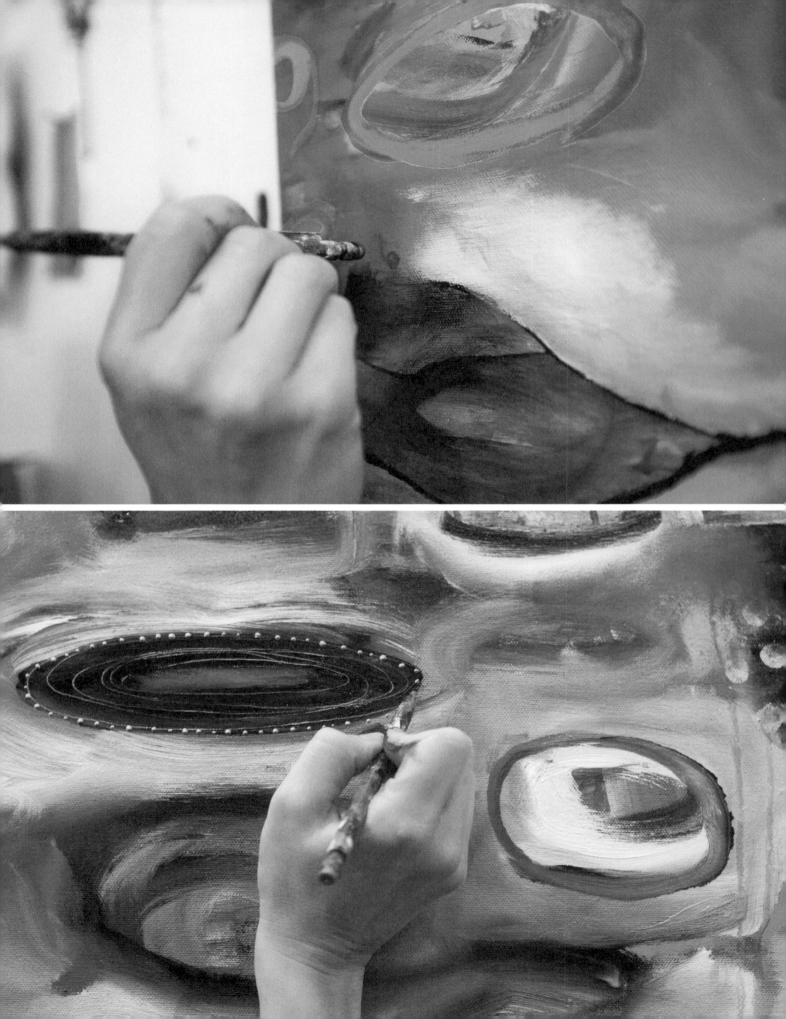

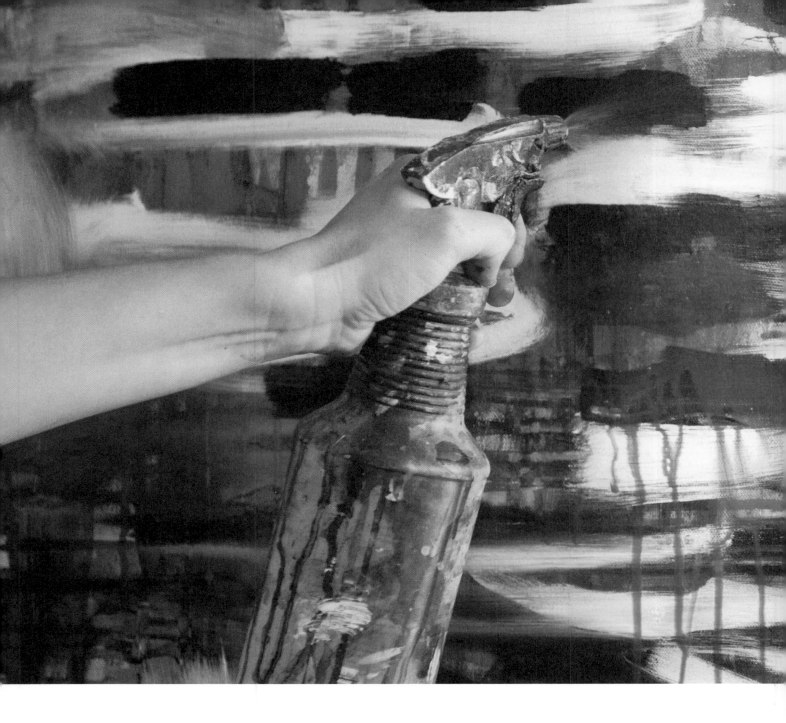

## SPRAY BOTTLE

Spraying water directly onto wet acrylic paint is an exciting process and can lead to some very interesting looks and unexpected surprises. You will find that spraying water onto fluid acrylics is more effective than spraying onto heavy-bodied acrylics. Fluid acrylics become even more fluid when water is added. Dripping, pooling, and mixing together, fluids behave more like watercolors, whereas heavy-bodied paint can be globby and resistant to flow. Spraying water onto your canvas is a great way to diffuse an area, soften an edge, or add a watery effect to your painting. I often begin my paintings with nothing more than some bottles of fluid acrylics and my spray bottle.

## ✳ PROMPTS ✳

- Place your canvas on the floor and drip some fluid paint onto your canvas from above. Now spray water directly onto your wet paint and watch as it pools and spreads.

- Tip your canvas up to create drips and lines.

- Spray water into your paint as it is dripping down your canvas.

- With your painting on the wall or an easel, spray water directly onto an area of wet paint.

- Turn your canvas ninety degrees to the right as your paint is dripping.

- Soften a hard edge by spraying water onto the edge and dragging your rag through this area.

- Use the stream setting on your spray bottle to create a strong blast of water onto your painting. Using this setting can actually remove paint with its force.

# COLOR LOVE: KEEPING COLORS FRESH

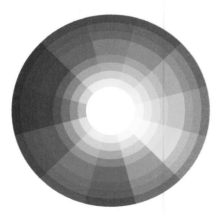

Now that you have a new toolbox of supplies and many techniques for applying paint, it's time to boldly experiment, play, and express your unique personal voice as you move paint around the canvas. Before you start, here are some notes on color to help you better understand color theory.

The power of color is profound, and it plays a vital role in our everyday lives. Beyond the universal messages of red meaning "stop" and green meaning "go," color has the ability to sway thinking, evoke emotions, change moods, and affect behaviors. Different colors can irritate or soothe our eyes, raise our blood pressure, or ignite our appetites. Many cultures have a wide variety of symbolism associated with color, and ongoing studies continue to reveal more and more ways that colors affect our everyday lives. I personally love to use color in ways that surprise, delight, and breathe vibrant life into my paintings.

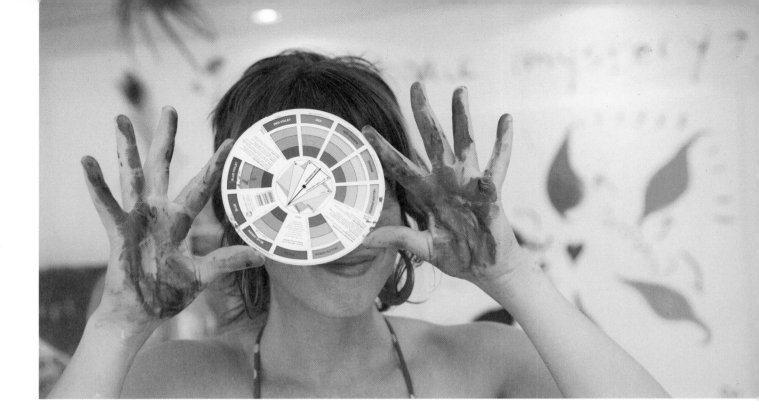

## THE COLOR WHEEL

This handy tool was first designed by Sir Isaac Newton and has been used widely to understand color ever since. Keep in mind that entire books are written about color theory, but for the purposes of this book, I will present some simple, effective, and fun tips on color that will help demystify color theory and allow you to play with the infinite possibilities held inside the rainbow. Let's start with some color wheel basics.

The wheel's construction is actually quite simple. There are six basic colors: red, orange, yellow, green, blue, and violet. Some wheels will show extra "in-between" colors that are mixes of the basic colors.

The **PRIMARY COLORS** are red, yellow, and blue. These three colors cannot be mixed or formed by any combination of other colors. All other colors are derived from these three hues.

The **SECONDARY COLORS** are orange, green, and violet. These three colors are formed by mixing two of the primary colors. For example:

> Red + Yellow = Orange
> Yellow + Blue = Green
> Blue + Red = Violet

The **TERTIARY COLORS** are the "in-between" colors such as blue-green, red-violet, and yellow-orange. These colors are formed by mixing a primary and a secondary color. There can be endless combinations of tertiary colors, depending on the base colors from which they're derived.

Now let's look at some different color schemes that you might to choose to incorporate into your paintings.

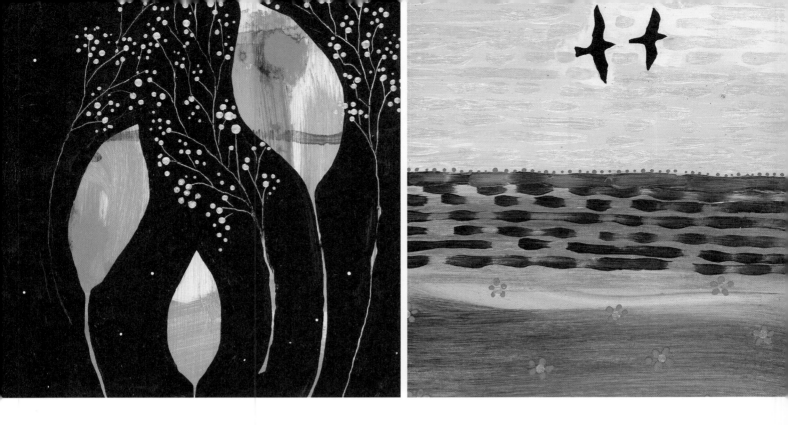

## COMPLEMENTARY COLORS

Colors that are opposite each other on the color wheel are called complementary colors. When complementary colors are used next to each other, their high contrast creates a vibrant look that pops and draws attention. Using complementary colors is a bold move that will make your painting come alive, but remember, if you use too many complements, the strong contrast can be overwhelming.

Examples of complementary colors:
Red and Green
Blue and Orange
Yellow and Violet

## ANALOGOUS COLORS

If you think of the color wheel as wedges of a pie, the colors in any one-fourth of the pie are analogous. These sets of colors are all found next to each other on the color wheel. They usually match well and create serene and comfortable designs. Analogous color schemes are often found in nature. They are harmonious and pleasing to the eye. When using analogous colors, you may want to add small bits of contrasting colors to liven up the palette.

Examples of analogous colors:
Red, Orange, and Yellow
Green, Blue, and Violet
Yellow, Yellow–Green, and Green

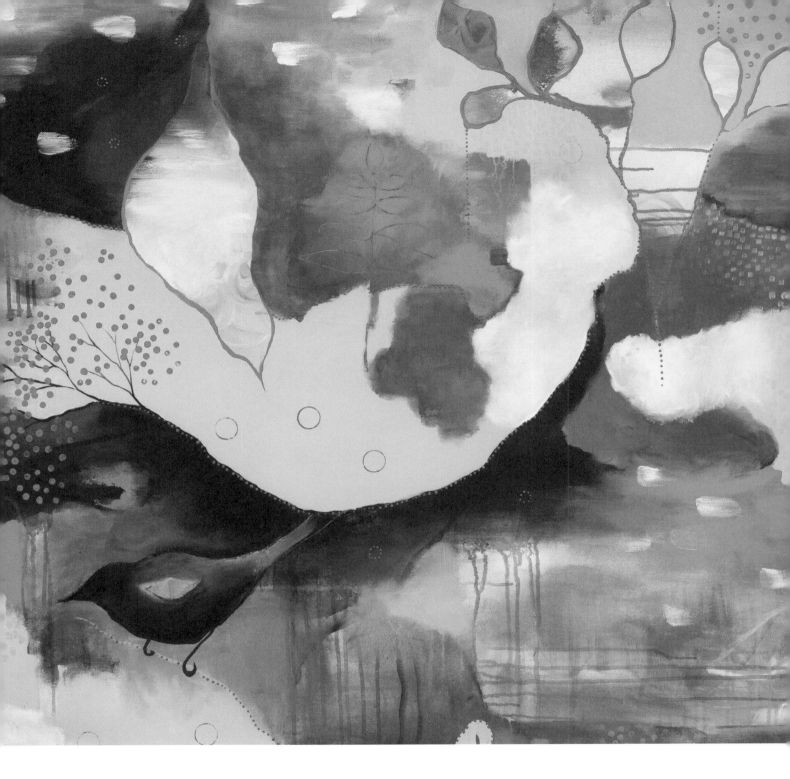

## COLOR TRIADS

A triadic color scheme uses colors that are evenly spaced around the color wheel. Place an equilateral triangle on the wheel to find one of these vibrant color schemes. The most basic color triad is made up of the three primary colors: red, yellow, and blue. The secondary colors create a triad of green, purple, and orange. Using a triad color scheme can create a dynamic yet balanced feel in your paintings.

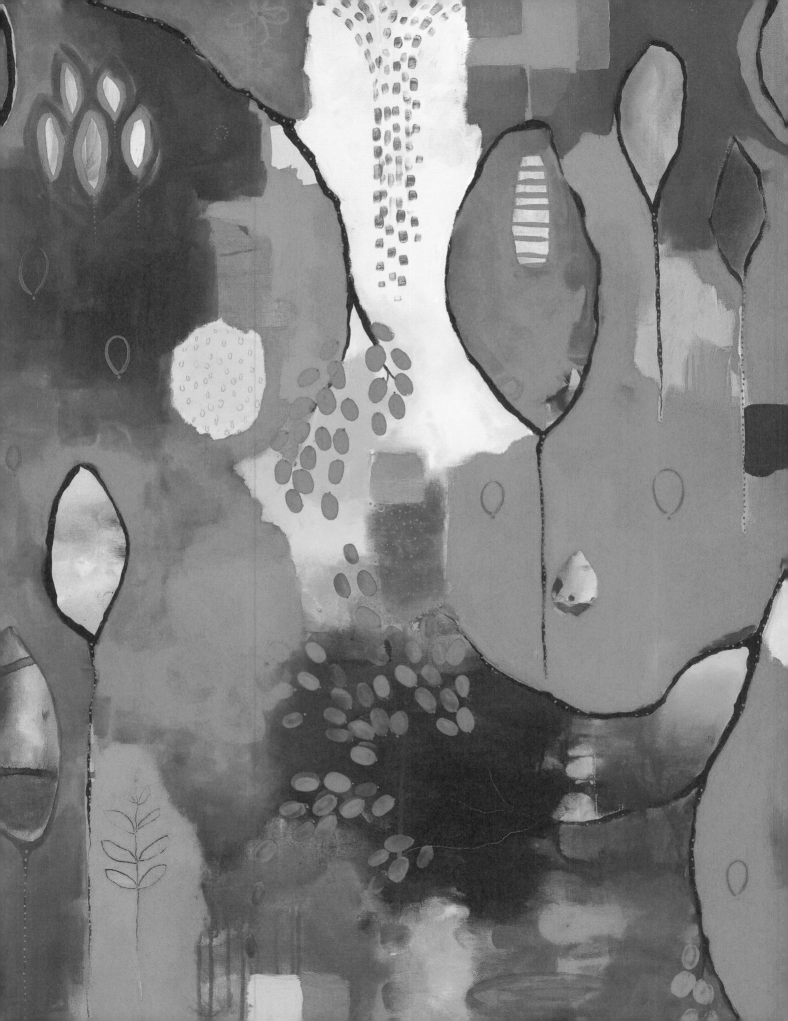

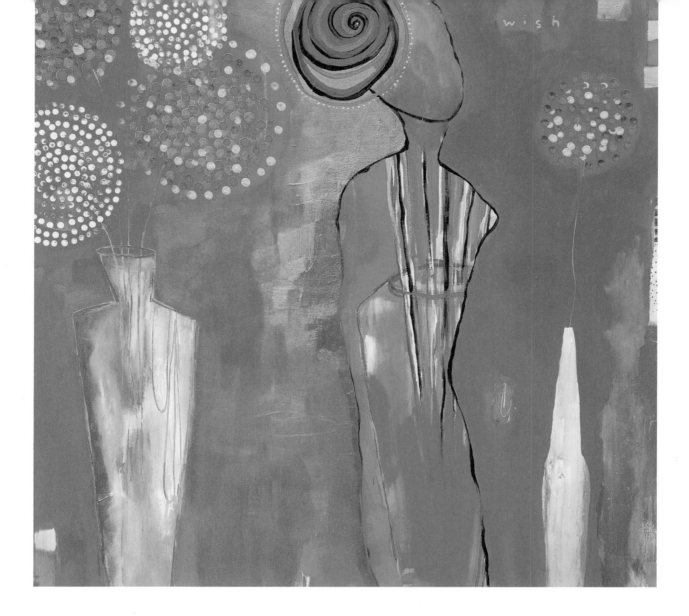

## WARM AND COOL COLORS

Another way to look at the color wheel is to divide the wheel into warm and cool colors. Warm colors such as red, yellow, and orange are vivid and energetic and tend to come forward in space. Cool colors such as blue, green, and purple often feel calm and create a soothing impression. White, black, and gray are considered neutral.

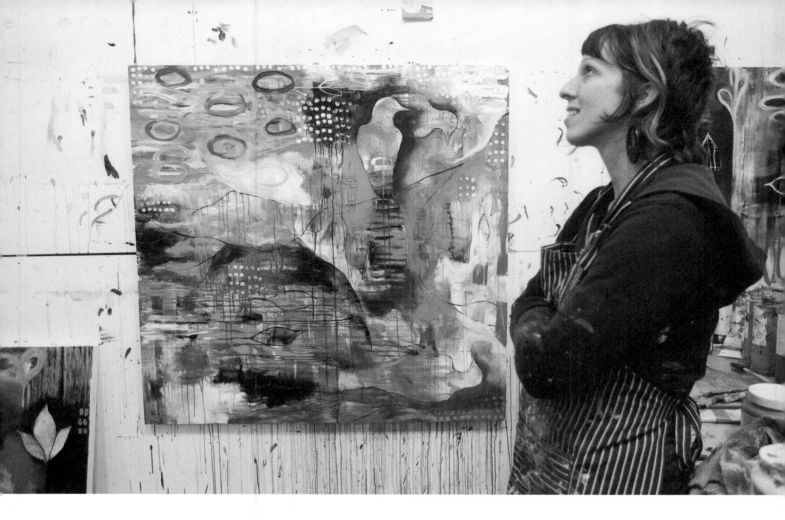

## STARTING WITH THE RAINBOW

If you find yourself feeling perplexed or overwhelmed with seemingly endless color options, remember you don't have to know what colors your paintings will become before you start. In fact, it's better if you don't! I hope this relieves any worries, such as which colors to use, how many to use, and how to combine them. Let those questions dissolve and consider that every color is simply an opportunity. Start with this perspective, and you'll be in a great position to allow your palette to emerge naturally in its own time.

I rarely have any idea of a color scheme before I begin painting. I prefer it this way. Instead, I start with the rainbow. I begin by adding the six basic colors from the color wheel along with black and white to my palette. I also add any other colors I'm feeling particularly

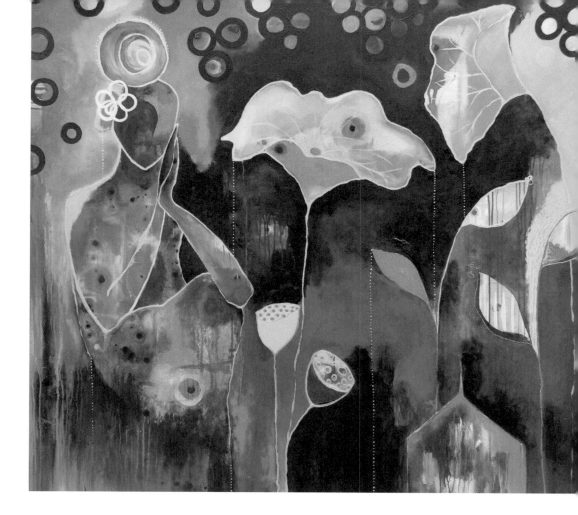

drawn to in the moment. I incorporate all these colors into the first layers of my paintings. I try not to think too much about color at this point. I simply want to give myself lots of options. With experience, you will learn intuitively how to mix colors without creating mud, and the next section will give you some great tips to get you started.

After building up three or four layers with the rainbow of colors, I eventually start to step back and notice which sets of colors are the most interesting, harmonious, or unique. I don't look at my paintings from a "color theory" perspective. I look for what makes me happy, causes my heart to beat faster, or simply draws me in for deeper exploration. For example, if an area of teal, orange, and green look appealing, I start to incorporate more of these colors into the next layers. At the same time, if red is distracting, I will start to cover up some areas

of red. I am careful not to cover up all the red, because these little bits of red might support, excite, and round out my entire color scheme in the end.

It's very important to understand that the choices you make about color are not permanent. Your love for teal, orange, and green may fade as a new combination of colors becomes more interesting. This is perfect. Follow your intuition. By doing so, you are allowing your palette to emerge naturally, giving your painting a deep and layered look—full of colors, full of life. There are no rules about color here. Make up your own rules and remember to break those too. However, as you're starting out, it may be helpful to eventually choose one color to dominate, a second to support, and a third as an accent. Have fun with the rainbow and dive into the spectrum of possibilities!

## STRATEGIES FOR KEEPING COLORS FRESH

Now that you have a basic understanding of
the color wheel and how to incorporate the
rainbow, let's discuss some easy tricks to avoid
creating mud out of all your vibrant colors.
To begin, make sure you always have at least
two canvases in progress at all times. This
is a crucial part of the process, as it allows
one canvas to dry as you work on the other.
You can easily move back and forth between
these canvases, adding wet paint on top of
dry layers without worrying about creating
mud. Remember when you add wet paint
to wet paint, the risk of making mud greatly
increases.

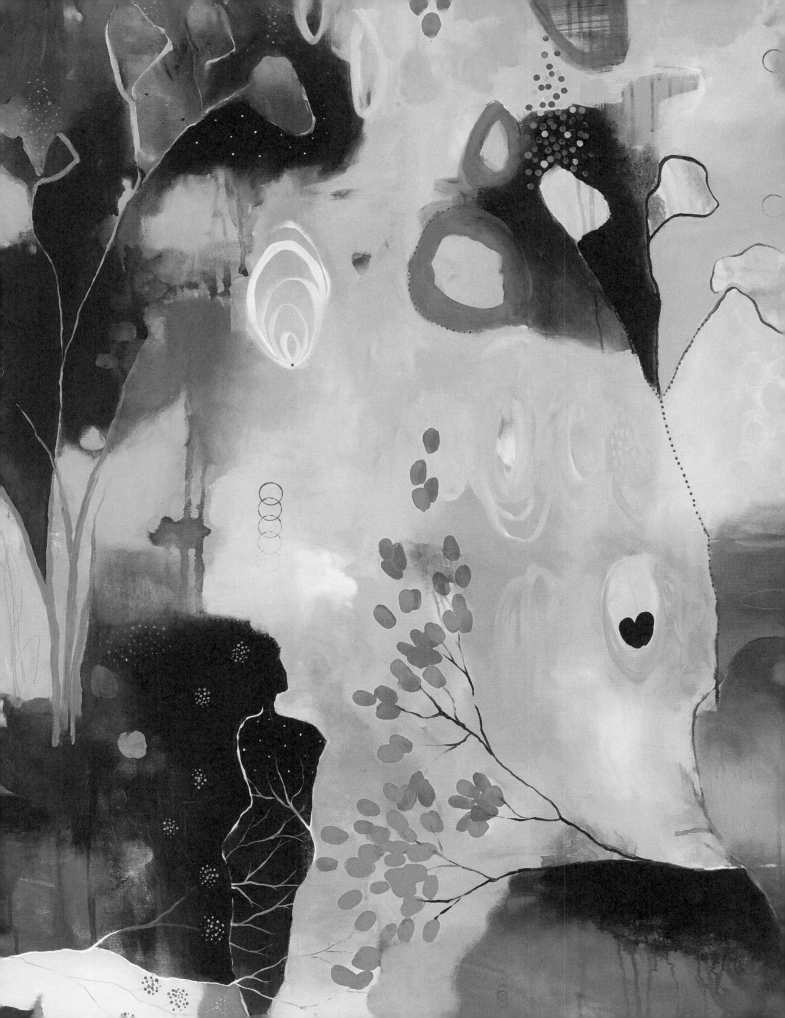

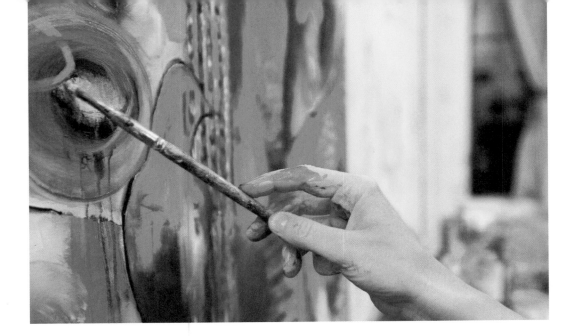

## ALTERNATING WARM AND COOL COLORS

Mixing warm and cool colors, such as orange with blue or yellow with violet, will *often* create mud. As you are learning about combining color, a great trick to keep your colors fresh is to separate your warm and cool colors. For example, start by painting with only warm colors … yellows, reds, and oranges. These colors will always blend well, so there is no chance of making mud here. Using only warm colors, play with the prompts, familiarize yourself with your tools, and give yourself an energized first layer of paint. Most likely, this layer will be completely covered up in your final painting, so don't worry about what it looks like. The focus here is on experimentation, play, and having fun. By experimenting with all of your tools and prompts, you will end up with a wonderful array of varied marks and many possibilities to build.

After your first canvas is wet with warm colors, set it aside and allow this layer to dry. Continue painting in a similar fashion with warm colors on your second canvas. By the time your second canvas is covered in paint, your first canvas will most likely be dry. If not, add a third canvas into your rotation or take a stretch break. When your first canvas is dry, pick up a new, clean brush and start playing again—this time with cool colors, such as blues and greens. Continue building up layers in this way, making sure the warm colors are dry before adding your layers of cool colors. By keeping your warm and cool colors separate, you will keep your paintings mud free.

With practice, you will intuitively come to understand which colors mix well and which colors will end up muddy. Simply put, the colors that are next to each other on the color wheel (analogous colors) will mix together easily. Colors that are opposite one another on the color wheel (complementary colors) will create mud. Keep your brushes separated by warm and cool colors. The more brushes you use, the easier it is to keep them fresh and clean. Also make sure to arrange the colors on your palette in a way that makes sense to you. I prefer to keep my warm and cool colors on opposite sides of my glass palette with plenty of space between each color. Just remember that it is through the process of painting—and making mud—that many lessons are learned. Again, there are no mistakes, only opportuntites!

## COLOR COMBINATIONS THAT *WON'T* CREATE MUD

TWO PRIMARY COLORS:

Red + Yellow = Orange
Yellow + Blue = Green
Blue + Red = Violet

TWO ANALOGOUS COLORS:

Red + Orange = Red–Orange
Orange + Yellow = Orange–Yellow
Yellow + Green = Yellow–Green
Green + Blue = Blue–Green
Blue + Violet = Blue–Violet

---

## COLOR COMBINATIONS THAT *WILL* CREATE MUD

TWO COMPLEMENTARY COLORS:

Red + Green
Yellow + Purple
Blue + Orange

TWO SECONDARY COLORS:

Orange + Green
Green + Violet
Violet + Orange

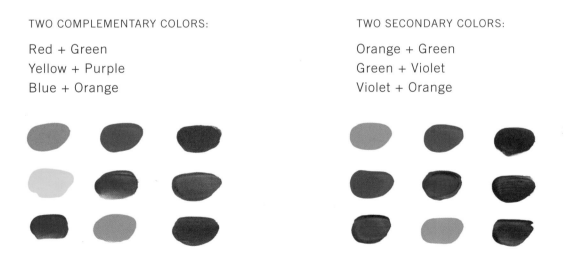

---

A SIDE NOTE: Acrylic paint dries very fast, so if your colors do get muddy, let them dry, then start with a fresh layer of paint.

## KEEP IT MOVIN':
## BLINDFOLDED FINGER PAINTING

Feeling daunted by your big, white canvas?
Blindfolded finger painting is a great way to
bravely and intuitively get your painting started.

Start by adding warm colors such as yellow and
red to your palette. Secure a large blank canvas
in front of you, either on an easel or on a table.
Turn up the volume on a song you really love.
Use a blindfold or close your eyes and keep them
closed as you paint with your hands and move
your body to the music. Instead of thinking, focus
on feeling the texture of the paint, the pulse of
the music, and the freedom of movement in your
body. Remember, it does not matter what this
layer looks like. Simply stay present and enjoy the
process.

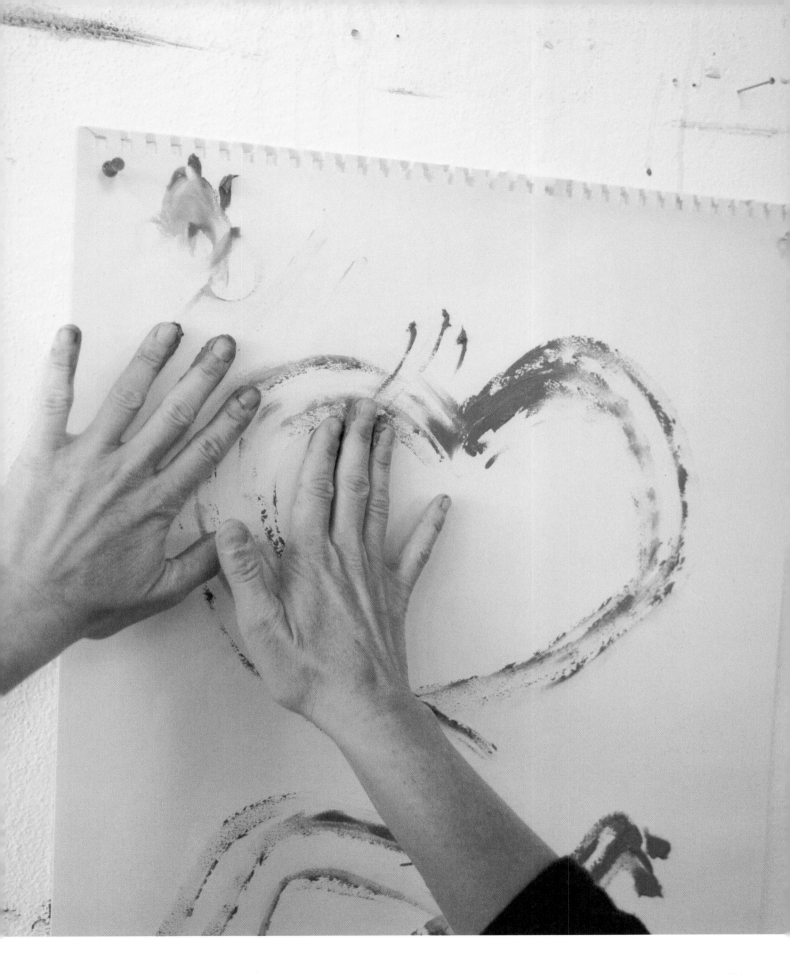

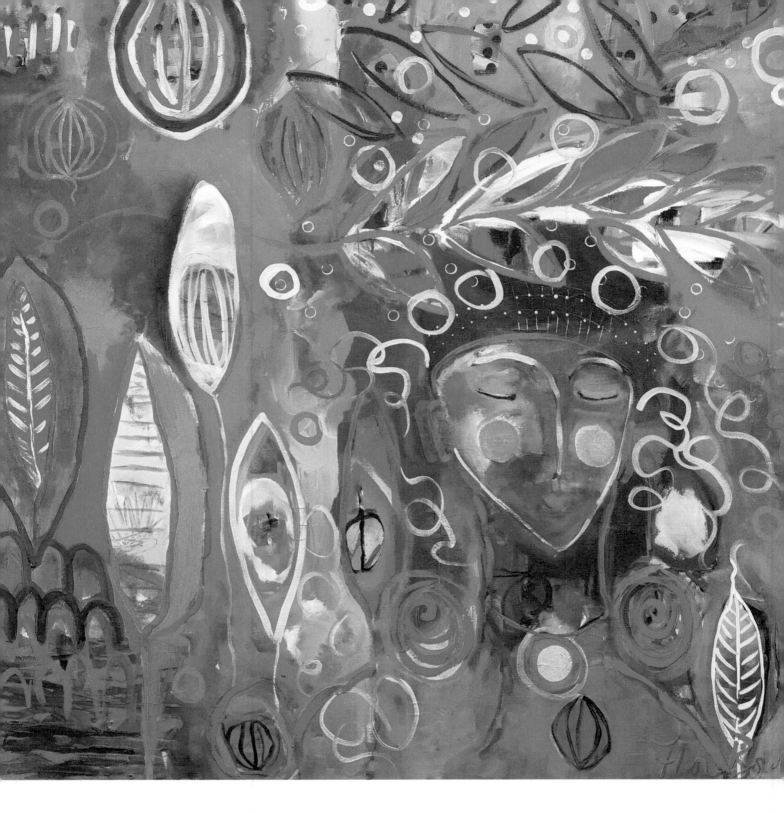

"Don't ask what the world needs. Ask what makes you come alive, and go do it. Because what the world needs is people who have come alive." —HOWARD THURMAN

# BRINGING YOUR PAINTINGS TO LIFE WITH VARIATION

The most effective way to bring a spark of life to your paintings is to incorporate lots of variation in your work, especially in the first few layers. You can vary every aspect of your painting including how you make marks, your line quality, value, composition, imagery, and texture. Keep in mind that every bit of variation creates an opportunity. Instead of applying paint in the same way with the same tools over and over again, mix it up. Be brave. Do something new. Surprise yourself. You will be rewarded with a rich canvas brimming with variation and full of infinite potential.

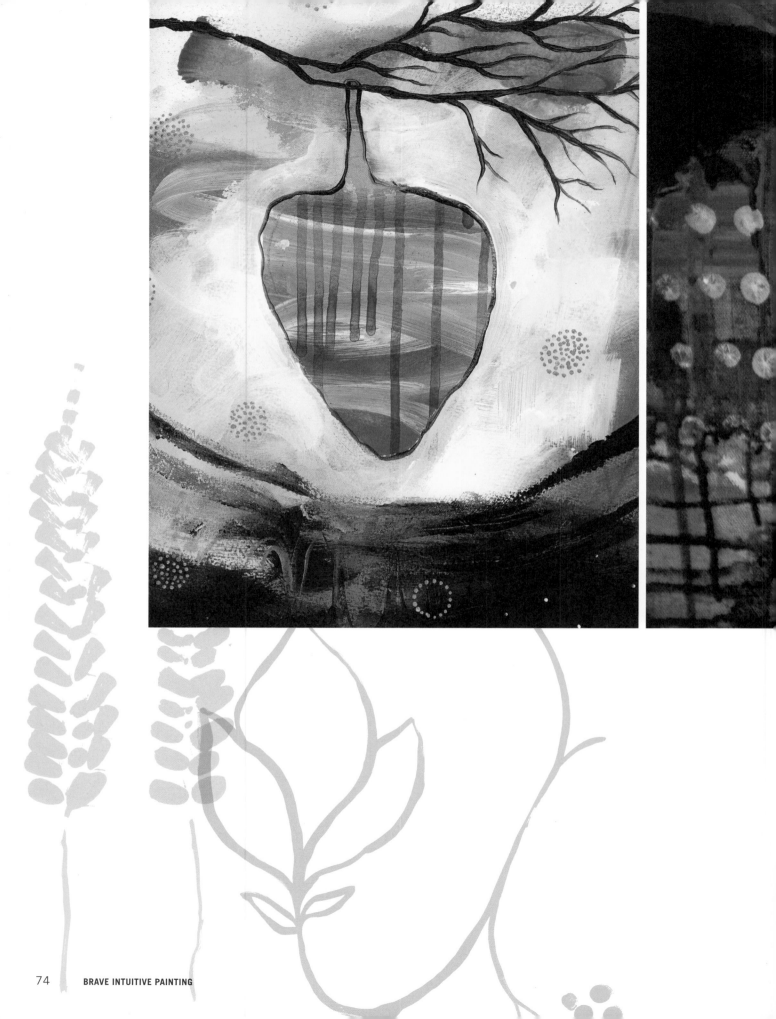

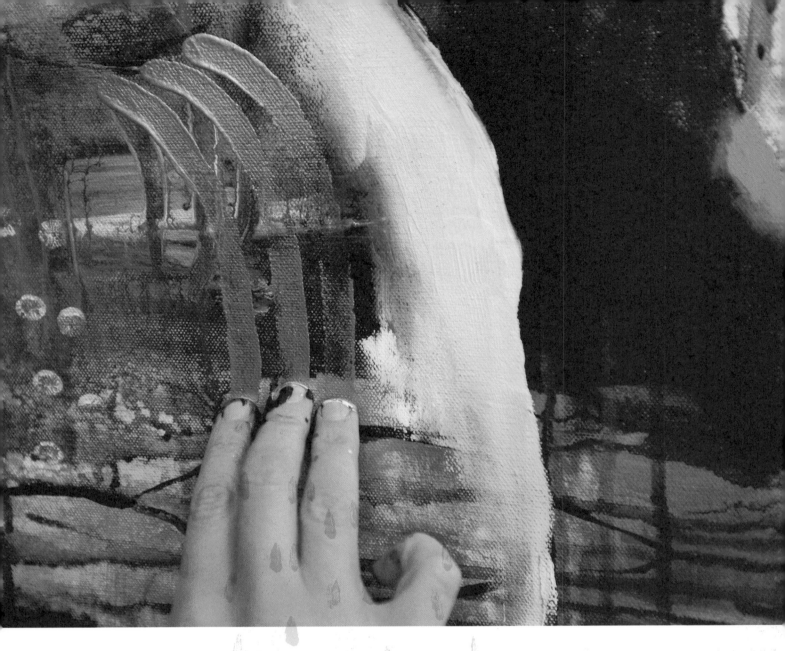

## VARIATION IN MARKS

There are infinite ways to make marks, but it's easy to fall into a rut. Take doodling: Is there a certain way you always doodle? Let go of these patterns and expand your marks into uncharted territory. Change the imagery, speed, and size of your marks. Explore the emotions or personalities behind your marks. What does an "excited" mark look like versus an "organic" mark? Let your marks tell the story. Don't worry about the way your marks look. This is an ideal time to loosen up, let go of how you "normally" work, and try something brand new.

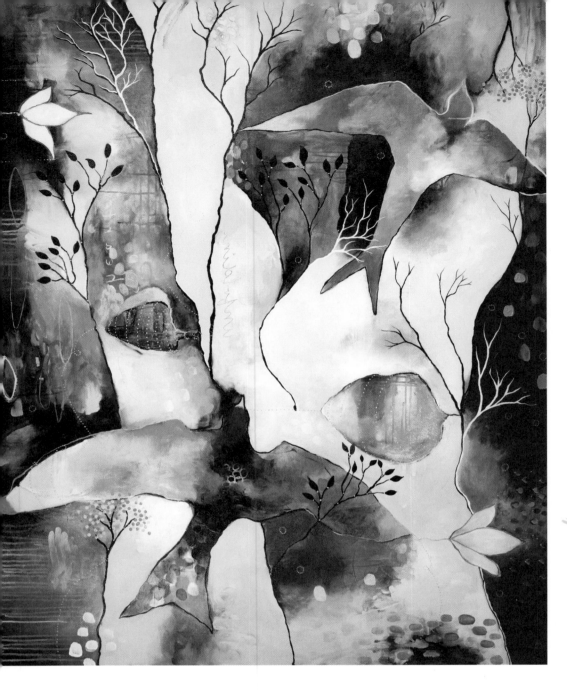

## VARIATION IN QUALITY

Giving your lines variation brings them to life. Look to the natural world and consider the depth of variation found there. Lines found in nature curve, spike, tangle, go from thick to thin, and are often in motion. This variation is what makes the natural world so intriguing and dynamic.

To achieve variation in your line quality, moisten your brush with water and load it up with fluid paint. Holding your brush loosely in your hand, slowly twirl and drag it across your canvas. This action allows the paint to release steadily off the end of the brush as you create your line. Play with pressure to create thick and thin lines. How much variation can you create in one continuous line? Paint curvy, organic lines. Paint sharp, jagged lines. Experiment with tempo and speed. In what other ways can you bring your lines to life?

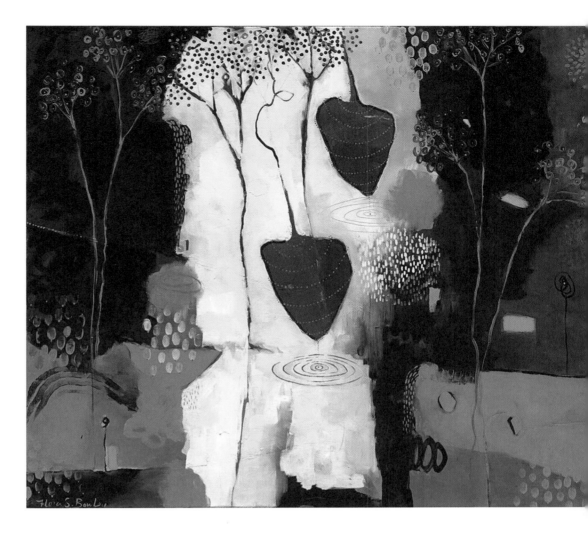

## VARIATION IN VALUE

For a long time I was afraid to use black in my paintings, but now I understand the importance of incorporating dynamic value contrast as a way to bring energy into my artwork. Value refers to the scale of light to dark, white being at the lightest and black being at the darkest end of the spectrum. By adding white or black (or other light or dark colors), you can lighten or darken any color to affect its value. I encourage you be bold

with your range of values. Make sure there is a broad spectrum, including some very light lights and some very dark darks present in your paintings. If you squint your eyes and all the colors look like they are the same value, add in some darks and lights by shading (adding black) and tinting (adding white) to your colors. Placing lights and darks right next to each other will be especially eye-catching.

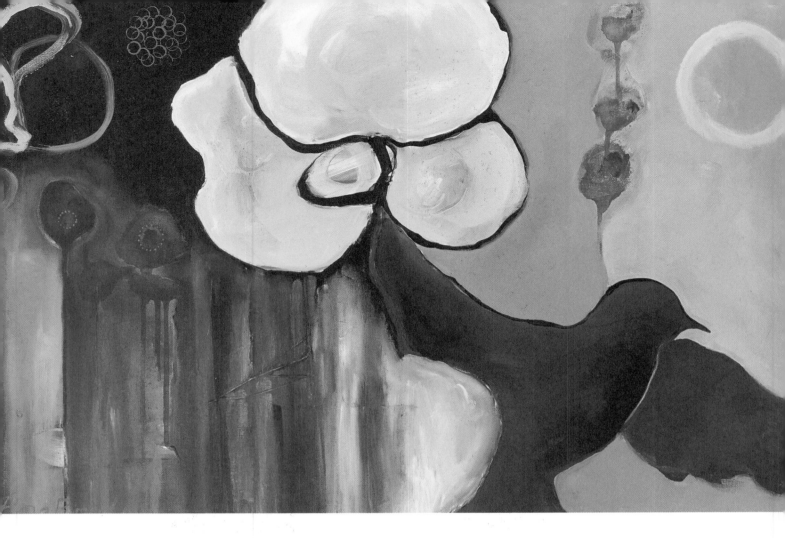

## VARIATION IN COMPOSITION

Great compositions feel natural. They may or
may not follow traditional compositional "rules"
such as dividing your canvas into thirds, using
uneven numbers of objects, or creating specific
focal points. Great compositions simply feel
right. Let go of predictable compositional
layouts and follow your impulses. Step back
often and notice how your eyes move around
the canvas. Are you drawn to one place? Do
you get stuck there, or does this place lure you
in and facilitate the movement of your gaze? Is
there a sense of harmony or tension in the way
the elements of your painting are arranged on
the canvas? Is your composition exciting? Or
could it use a new twist?

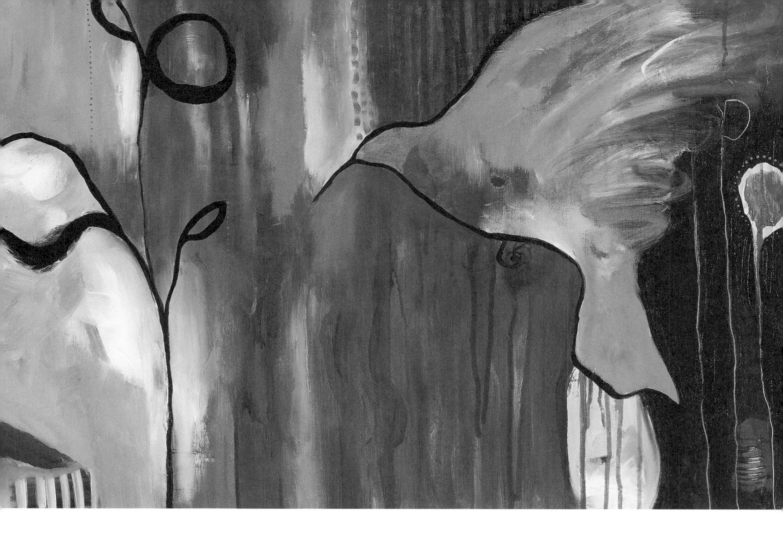

To avoid falling into a compositional rut, continually strive to diversify your approach and make up your own rules. Some helpful approaches might be to vary the size of your shapes and how they are laid out, where you put horizon lines, and where you put focal points. Allow shapes and lines to extend past the edges of the canvas. Try painting on both portrait (vertical)- and landscape (horizontal)-shaped canvases. If you are incorporating perspective, mix it up. By letting go of a formula, you open yourself up to infinite compositional possibilities.

## VARIATION IN IMAGERY

It is easy to become comfortable with imagery that you've used in the past or imagery that is easy for you to draw. It's also tempting to "borrow" from other artists, but this serves no one. Let's focus on ways to keep your images fresh, interesting, and authentic to *you*. Over time, as you listen to your intuition, your true voice will become stronger and more clear. To encourage this process, get in the habit of sketching the world around you. This is *your* unique life, and it's full of inspiration when you remember to really see it. Remember to sketch both the big-picture elements and the little details. There is beauty in all of it.

Another way to expand your visual language is to collect objects and images that have a deep personal significance to you or that you simply find attractive. Notice what collections you already have. These heartfelt items might make for some very interesting and emotionally charged subject matter. Take lots of photographs and make prints of the images you find most intriguing. You may choose to draw upon these images in your paintings. You may choose to leave them behind. Either way, taking photographs will encourage you to literally see your life through a new lens. This can also be a great way to practice working with new compositions. Notice what objects and images you are drawn to. This will

steer you toward developing a unique visual language that is truly your own.

A completely different way to approach imagery is to allow images to emerge organically, much like finding shapes in clouds. To do this, step back from your canvas and soften your gaze. Does anything appear? What happens if you turn your canvas in a different direction? I often change the orientation of my canvas several times before deciding which way is "up." This is a great way to let go, keep your work fresh, and open yourself up to new possible imagery. Interesting, unpredictable images often appear when you give them the space to emerge. If nothing magically appears, don't worry ... just keep painting. There is *also* tremendous power in letting go of imagery altogether. What might emerge in the place of recognizable imagery? The world of abstraction may be eagerly waiting for you to discover it.

Remember that generating your personal style is a lifelong process that takes dedication. Recognize your deepest impulses to paint new images, colors, or abstract lines when they arise. Let these creative urges manifest, even if they don't "make sense" or "look good." Follow your intuition and let your voice be heard.

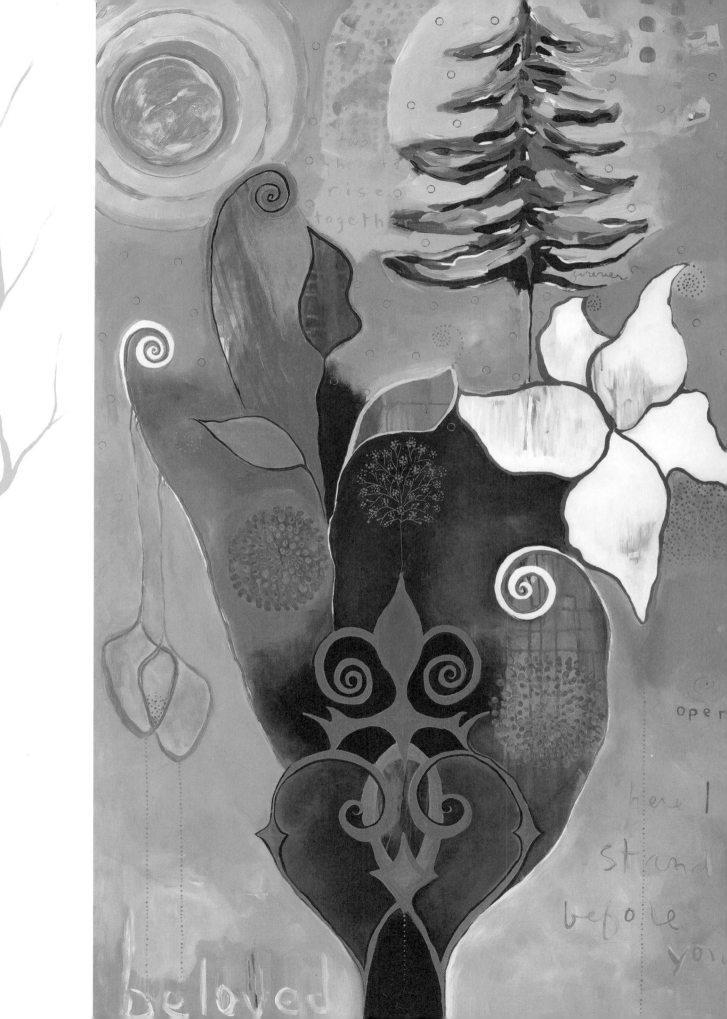

two
hearts
rise
together

forever

oper

here I
stand
before
you

beloved

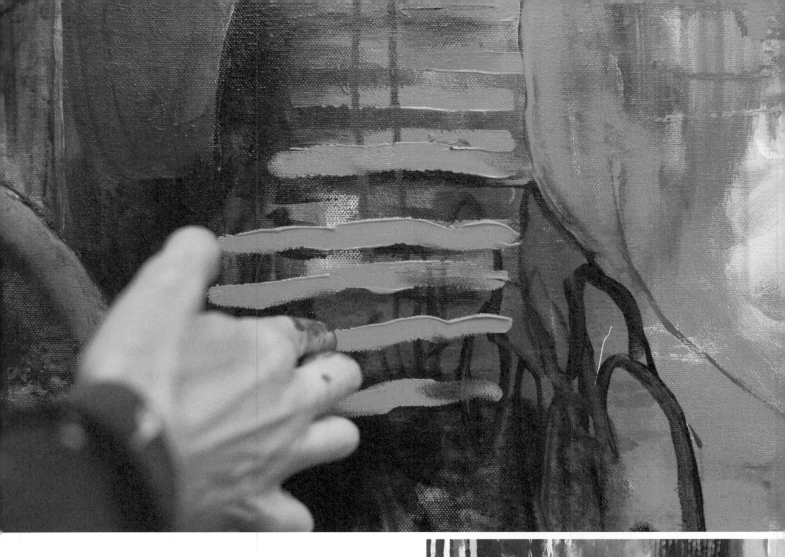

## VARIATION IN TEXTURE

Thick paint used alongside thinner areas of paint, even raw canvas, can add an unexpected element of contrast into your paintings. Use heavy-bodied paint to build up thick, buttery areas and use fluid acrylics for a more transparent or washed look. You can also etch, stamp, and use your rags to add more textural variation. Don't be afraid to use your paint; that's what it's there for. Using lots of paint will make for more finished-looking paintings. Boldly scoop up paint with your fingers or a brush and have fun moving it around your canvas as you build up varying layers of depth.

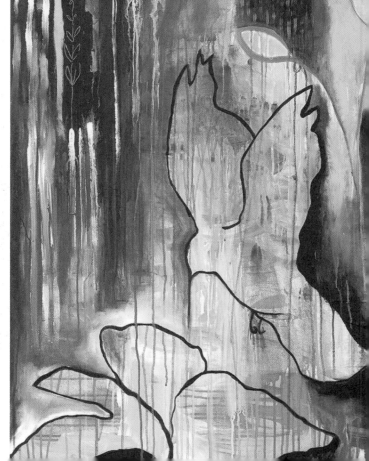

# BE BRAVE CHALLENGE: VARIATION—THE SPICE OF LIFE

Now that you're familiar with the many ways that you can bring your paintings to life with variation, let's put these concepts into action. Respond to these six prompts using a different surface (the bigger, the better) for each exercise. Work quickly and intuitively.

1. **Mark Making:** Using a variety of tools, create marks which embody the following characteristics: timid, fluid, dainty, angry, jagged, happy, wild, confused, and bold. Allow your marks to overlap and intermingle. Do they tell a story?

2. **Line Quality:** Using only sticks or other natural materials dip your tool into ink or fluid acrylics and create a painting using only abstract lines. How many different kinds of lines can you make?

3. **Value:** Use one color of your choice plus black and white to create a painting with lots of value contrast. Do you see the entire scale from black to white?

4. **Composition:** Find three objects of varying size to use as your subject matter. Arrange these objects in an unusual way in front of you. Paint this still life allowing some of the objects to extend off the edges of your painting surface. Now rearrange them and paint your new composition on top of the first arrangement. What kind of composition can emerge?

5. **Imagery:** Ask a friend for five nouns (do not tell them why). Now create a painting using these five images. Do your images tell an interesting story?

6. **Texture:** Squeeze some paint directly out of the tube onto your painting surface. Use a brush, your hands, and another object to move the paint around the surface. How many different textures can you create?

# TIME TO PLAY

Many of my favorite paintings are the ones I had the most fun creating. Staying in a playful state of being while you paint keeps you out of your logical mind and open to more possiblities and authentic moments. This is a great way to stay loose and avoid taking things too seriously … and it's simply more fun! We have a lot to learn from children in this department!

Play with many aspects of your paintings—color, imagery, words, and composition provide endless opportunites for playful moments. To stay in a playful place, try spontaneously "dancing" the paint around the canvas. Let your marks be quick and decisive—full of movement and life. Again, don't overthink. Allow your childlike impulses to move your brush around the canvas and hang on for a spontaneous ride. If you have an urge to paint a giraffe, paint a giraffe. If you want to use pink, use pink. Polka dots? Yes! Your playful ways are a gift to the world, so embody your five-year-old self and don't look back.

## KEEP IT MOVIN': FLOCKING

Experiencing playful movements in your body is an amazing way to loosen up, get out of your head, and become firmly grounded in the present moment. With at least three willing participants (kids love this) and some wide-open space, begin moving as a group. Allow one person to be in the front of your "flock." The flock leader comes up with a unique movement that may or may not also include a sound. The rest of the flock stays slightly behind the leader and mimics their movements. When the leader feels done, they simply peel off and go to the back of the group, and another person begins leading with a brand-new movement. This is a perfect time to fearlessly follow your instincts. Get bravely in touch with your playful self—even if that means your whole group is rolling down a hill or leaping wildly through the air. When you return to your paintings, notice how your playful ways might find their way into your art.

# A BRAVE NEW YOU

Both in life and in the creative process, there is a tangibly different feeling when you are experimenting boldly as opposed to simply going through the motions. Remember that being brave can mean being drastic or being subdued. Whatever brave looks like to you, listen to your impulses and jump in with both feet. Amazing things are bound to happen there.

In my workshops, I continually remind my students to "Do something bold." "Go out on a limb." "Surprise yourself." "Move beyond your comfort zone." These reminders are often followed by a slight feeling of panic, followed by a flurry of wild creative unleashing, often giving way to a new feeling of lightness. Charged with courage and trust, these brave actions often result in epiphanies that breathe new life into the room and into the paintings. Bravery feels good!

*"Life shrinks or expands in proportion to one's courage."*

—ANAÏS NIN

## BE BRAVE CHALLENGE: LIGHTING A NEW FIRE

The next time you find yourself stuck, frustrated, or uninspired, especially after you've been working on a painting for a while, do something you've never done before. Do something brave. Pay special attention to ideas that seem crazy, unrealistic, scary, or ridiculous. Don't think too hard. Act on the ideas as they spring into your mind, and watch what unfolds. Here are a few prompts to light your brave new fire.

- Turn your canvas upside down.
- Spray water into a large area of wet paint.
- Use black.
- Paint with both hands.
- Paint with your eyes closed.
- Paint the first word that pops into your mind.
- Use a brand-new color in a bold way.
- Cover up something you like to make room for something you love.

- Use pink.
- Look around the room and paint the first image you see.
- Create a new pattern.
- Drag your rag through an area of wet paint.
- Find a brand-new "stamper" and run wild with it.
- Follow your next impulse.
- Do it again.

"I want to stay as close to the edge
as I can without going over.
Out on the edge you see all kinds
of things you can't see from
the center." —KURT VONNEGUT, JR.

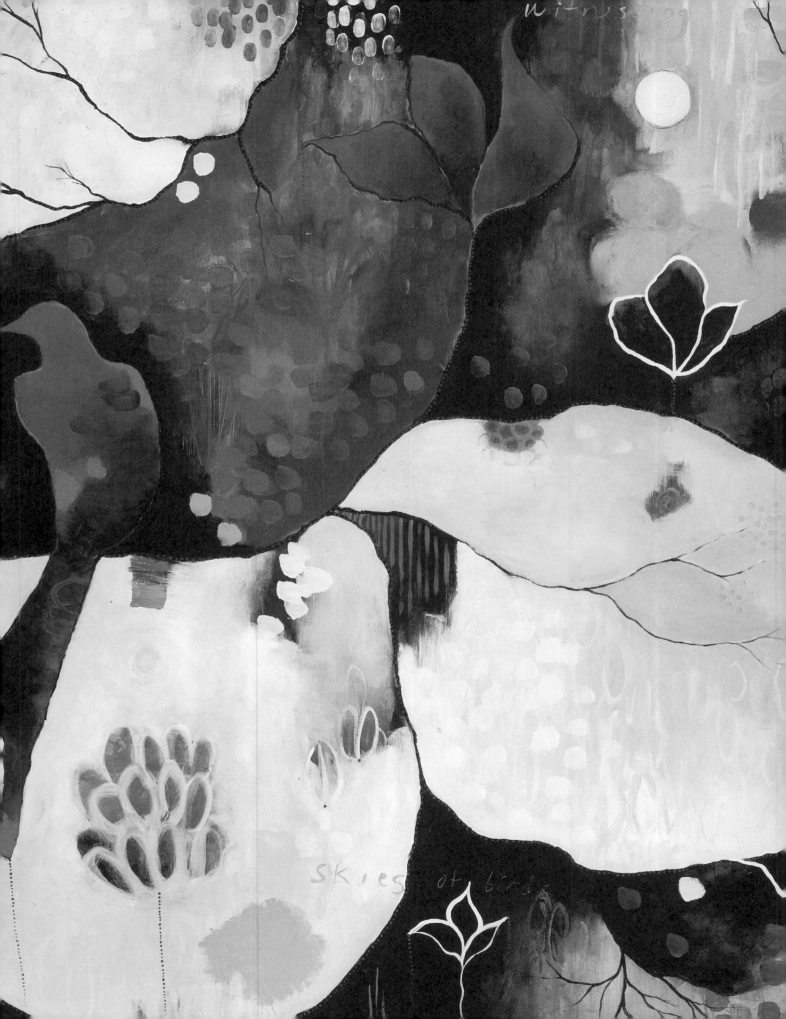

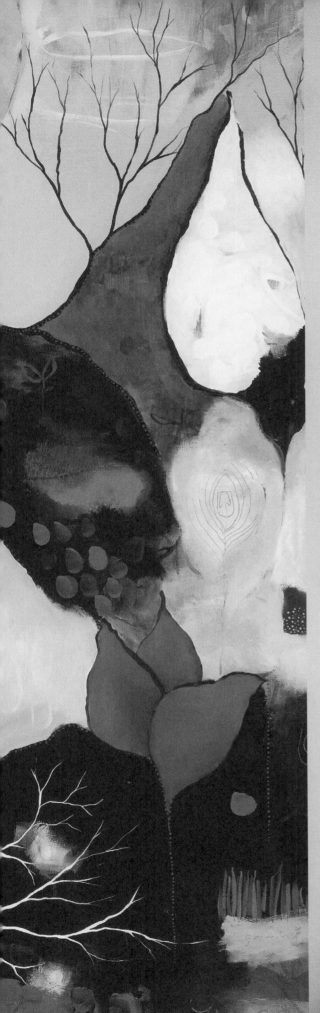

# UNFOLD:
# FINDING YOUR UNIQUE VOICE AND ALLOWING YOUR PAINTINGS TO BE BORN WITH EASE

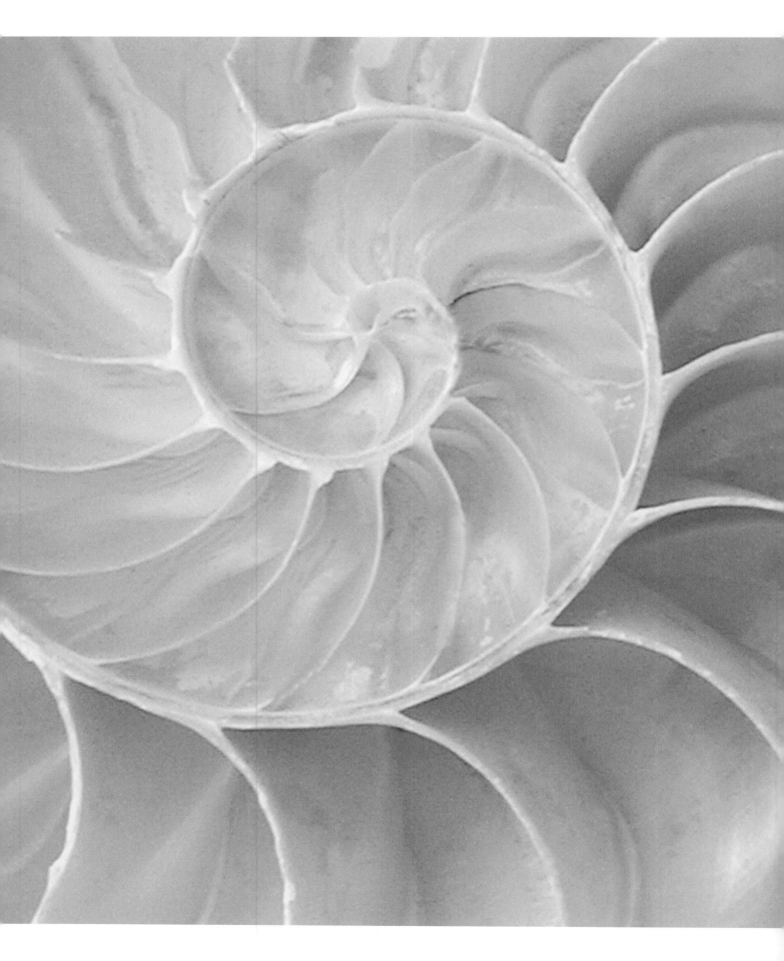

# SPIRALING IN AND SPIRALING OUT

Spirals are abundant in the natural world. They are found in hurricanes and tornadoes, in the patterns of seeds on a sunflower, in the growing tips of ferns, on shells, and even in our DNA. They represent cycles of time, balance, progress, expansion, growth, death, and rebirth. For me, spiraling also represents a way of painting. I approach my paintings from a place of wild and free letting go (see the "Be Bold" section) as well as from a place of contemplation, thoughtful choice making, and commitment to my vision. This is not a linear process. It does not travel from chaos to order or from order to chaos. Instead, this spiraling approach moves fluidly between letting go and making choices, integrating these equally important ways of painting along the way.

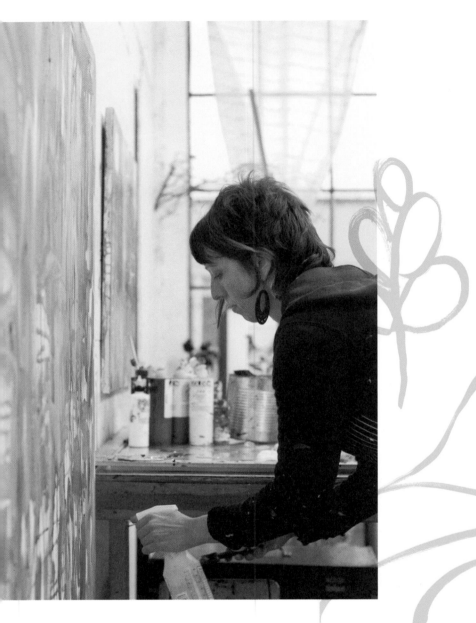

## SPIRALING IN

I consider *spiraling in* to be the moments when you are working with wild abandon, completely absorbed in your painting process, and moving from a place of pure intuitive expression. These are wonderful, timeless moments, so if the inspiration to keep painting is present, by all means, follow your brush! Work from a place of brave, spontaneous freedom and continue painting intuitively for as long as the forces guide you. You are in *the flow*— embrace it. This is your time to "let go," so don't hold back.

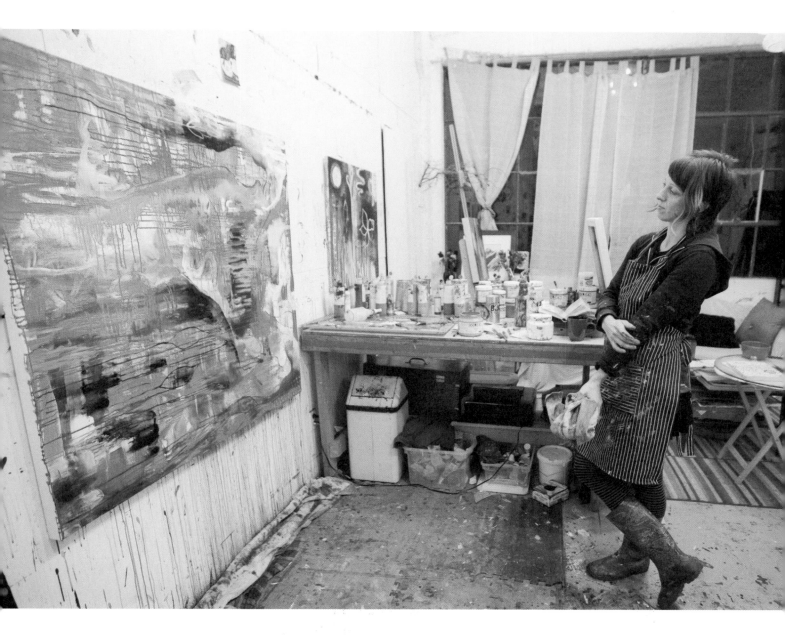

## SPIRALING OUT

When you start to feel tired, complacent, or stuck, this is the perfect time to *spiral out*. Stepping away or spiraling out from your paintings is a powerful tool that allows you to see your work with new eyes. As is true in life, when you are too close to something, eventually you can't see it at all. By spiraling out, you are gaining a new perspective that will support you to make new choices and push your paintings in new directions. This does not mean you have to decide the fate of your paintings in this moment—most

definitely not! You are simply giving yourself a fresh perspective to avoid getting "lost" in your canvas. By fluidly spiraling in and out as you build up layers, you are training yourself to move easily between pure letting go and thoughtful decision making ... a handy balance that will also support you in your everyday life.

The following section will guide you gently down a different kind of path—a spiraling path—leading to a world of dynamic painting from the heart.

# GETTING PERSPECTIVE AND WORKING WITH WHAT'S WORKING

We often look at the world through a critical lens. Traditional art school critiques encourage us to find what is not working in order to learn from these "mistakes." What I am presenting here is a new approach. I am kindly asking you to reprogram your response style; instead of focusing on what is *not* working,

ask yourself, "What *is* working?" This is an extremely important step in this process. It keeps you focused on the positive aspects of your work and offers you a starting point or a portal back into your painting. "Working with what is working" is especially useful when you are feeling stuck or uninspired.

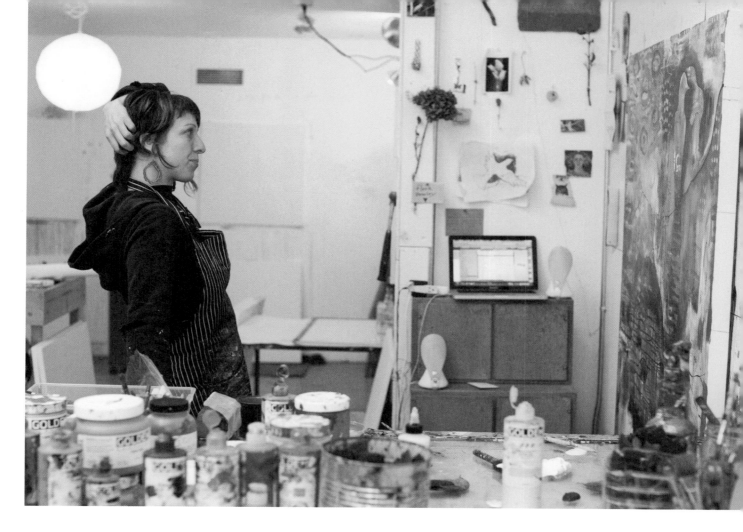

## WHAT *IS* WORKING?

After you have built up a few layers with a variety of marks and colors, spiral out by moving to the opposite side of the room, or to an entirely different room. I encourage you to do a little movement at this point, maybe a forward bend or a spiral twist (see the "Keep It Movin'" sidebar on the next page for more movement suggestions). Now soften your eyes and take a fresh look at your painting. Ask yourself, "What *is* working?" What is the first thing you notice? It can be anything. It may be one square inch of your canvas where the colors blend together in a certain beautiful way. It may be one interesting shape, a small area of etching, a dynamic line, or the way two colors vibrantly react next to each other. I also encourage you to ask yourself, "What has been the most enjoyable or interesting part of this process?" You may find that you really love spraying water, using your fingers, rendering certain images, or dragging your rag through wet paint. Pay close attention to these joyful moments … they are an essential part of "what is working" no matter what your painting looks like.

Be easy on yourself at this point. You are deep in the process of creating. Your paintings are not finished. They may feel ugly, chaotic, or overwhelming to you, but remember each and every mark is simply an opportunity. Most new creations go through an "awkward teenager" phase as they mature and figure out who they want to be. Don't judge them. Support them. Be patient with their process, and remember there are no mistakes. Growing up takes time.

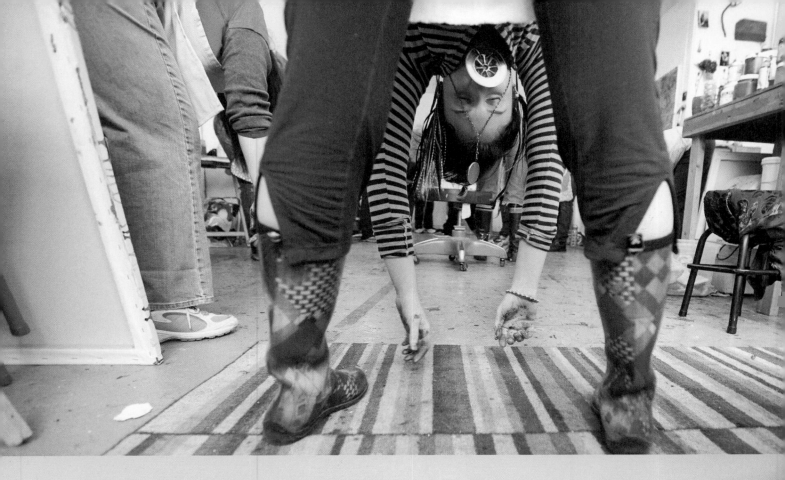

## KEEP IT MOVIN': SHAKE IT UP

Spiraling out is a great time to move your body and find your breath. Here are some prompts to get you started:

- Standing with your feet hip distance apart, stretch your arms high above you and then release into a forward bend. Keep your knees bent if that feels good. When you are ready, roll up, one vertebra at a time, letting your head come up last.
- Loosely swing your arms to the left and right as you twist your spine and look over each shoulder with each twist. Try speeding up and slowing down.
- Do jumping jacks.
- Make large circles with your arms to loosen up your shoulders.

- Press your hands into prayer position and drop them toward your stomach to stretch your wrists.
- Take a quick walk or jog around the block for energy.
- Lie on your back with your knees bent into your chest and your arms out like a *T*. Drop both knees to one side to twist as you look over your opposite shoulder. Repeat on both sides to release your spine.
- On your back, roll forward and backward on your spine until you stand up. Push your hands onto the ground to support you as you stand.

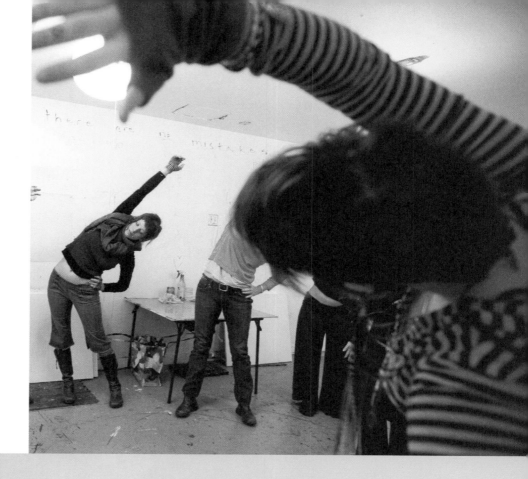

- Standing or sitting, drop your chin down to your chest to feel a stretch on the back of your neck. Slowly start to roll your right ear toward your right shoulder. Now roll to the left side and repeat this motion to loosen up your neck.
- Place your hands on the back of a chair or on the edge of a countertop. Walk your feet back and stretch your arms forward until you create an L shape with your legs and torso. Drop your head down and reach your tailbone up to the sky to elongate your spine and release your back.
- Standing, bend your knees slightly and gently bounce your whole body. Stay as relaxed as possible to wake up your senses and loosen any tension you may be holding.

- To practice Lion's Breath, take a deep breath in, look to the the ceiling, and extend your tongue actively toward your chin while you let out a loud exhale. This is a great way to release stagnant energy.
- To practice Tree Pose, balance on one foot as you bring the other foot to the inside of your opposite ankle or above your knee. Reach your hands in the air and concentrate your gaze on one fixed point.
- If you are able, do a handstand, a cartwheel, or a somersault on the ground. Swing from the monkey bars or climb a tree. Remember what it's like to play.
- Discover other ways to move your body that feel great for you!

# COMMITTING TO NOW AND KEEPING MOMENTUM

The word *commitment* can stir up all sorts of feelings, but there comes a point when committing to something—*anything*—creates a foundation to build on. After you step back and see what is working, integrate the information and commit *now* to your next bold move. Spiral out to see what's working. Don't linger too long here or you'll lose your momentum. Take your fresh perspective, spiral back, dive back into your painting, and expand on what is working. Based on what's working, your commitment may be to add more red, darken a line, or expand on a shape. It can truly be anything as long as it provides a starting point—a solid place for you to move forward. The good news is that you can always change your mind. Commit fully, but stay flexible.

*"The irony of commitment is that it's deeply liberating—in work, in play, and in love."*

—ANNE MORRISS

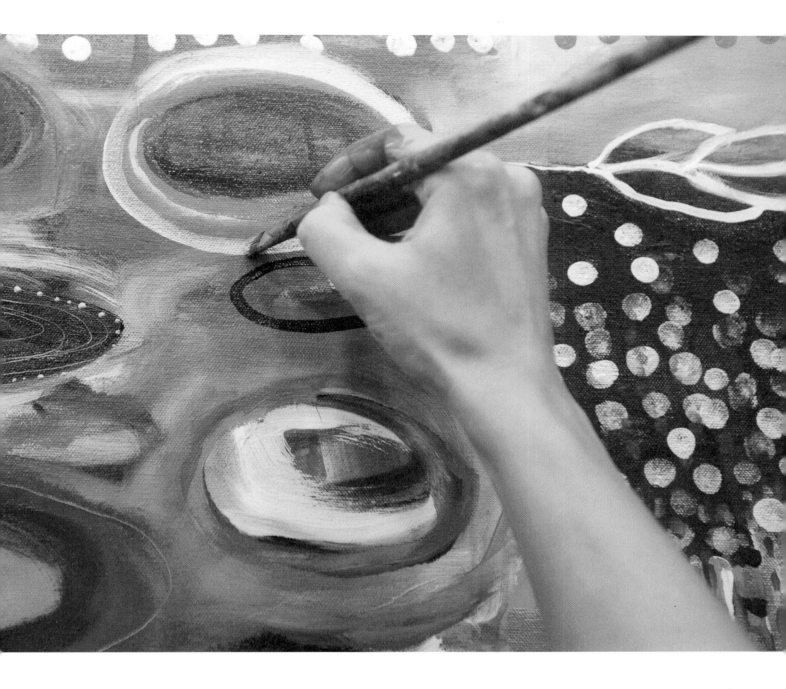

## DON'T HOLD BACK

Don't be afraid to go overboard with your commitments. For example, if the thing that is working is the circle in the bottom left corner, make more circles. Go overboard with circles. Make big ones and small ones. Use different colors. Play with how many different ways you can create circles. Allow your whole painting to be about circles … *for now*. Your painting might not *always* be about circles. It will most likely morph into *something* totally different. But by picking something to commit to, you keep your momentum, create many options, and develop a canvas rich with history and layers.

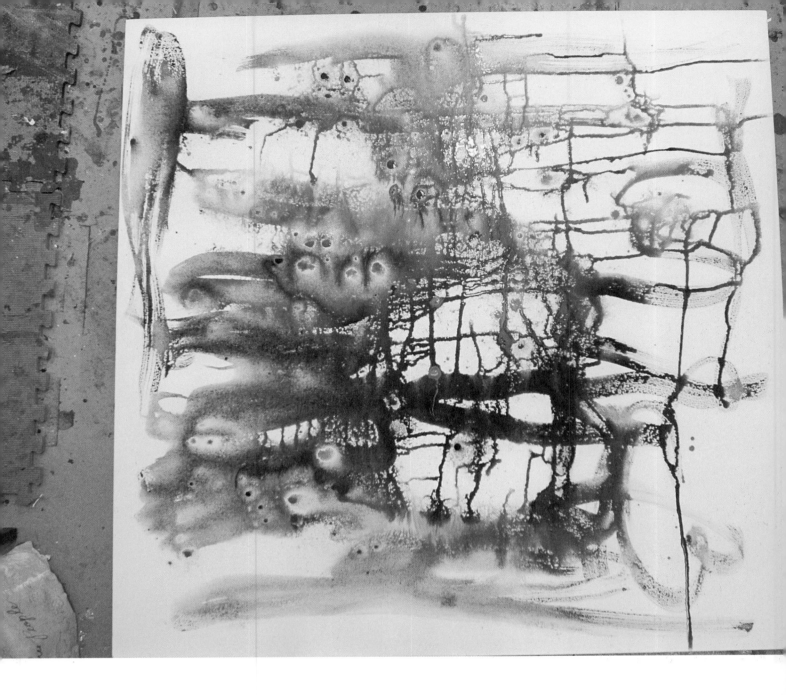

"You have to leave the city of your comfort and go into
    the wilderness of your intuition. What you'll discover will be
wonderful. What you'll discover is yourself." —ALAN ALDA

## CONNECT: SOMETHING OUT OF NOTHING

One of my favorite childhood games was to create a complete drawing out of a few circles or lines. I used to beg my mom for more scribbles, so I could expand them into my own little creative world. This is essentially how I create my paintings as an adult. On paper, start with a few quick gestural lines or have a friend create some marks for you. Step back, take a look, and follow your gut instinct as you choose one area to expand on. Let this area lead you to the next. Perhaps those fleeting marks morph into a creature, a landscape, or an abstract drawing. Work fast and intuitively on many drawings in this way. Watch with curiosity as your creation comes to life out of a few quick lines. Allow this practice to find its way into your painting process.

# ALLOWING YOUR PAINTING TO EMERGE NATURALLY

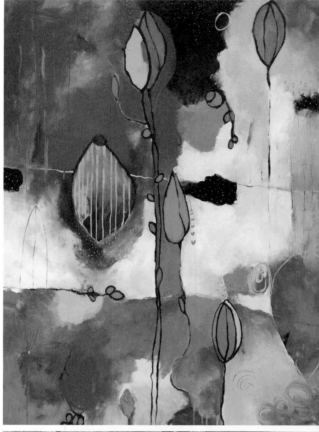

Allowing your paintings to emerge organically creates the basic foundation for this painting process. Thankfully, it's a forgiving and fun way to work, and it's new every time. Start by letting go of what you *want* your paintings to look like. This may be difficult, I know, but in doing so, you give yourself the true gift of possibility. Anything can happen now. You are making space for your paintings to reveal themselves as they were meant to emerge without having to fight against preconceived ideas in your head. This is a wonderful way to release any pressure and discover what is living just underneath your rational ideas and comfortable patterns.

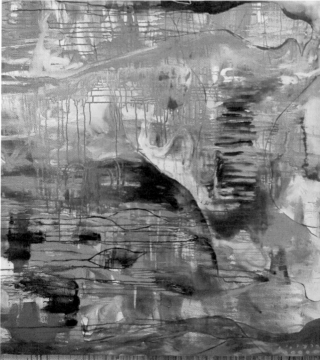

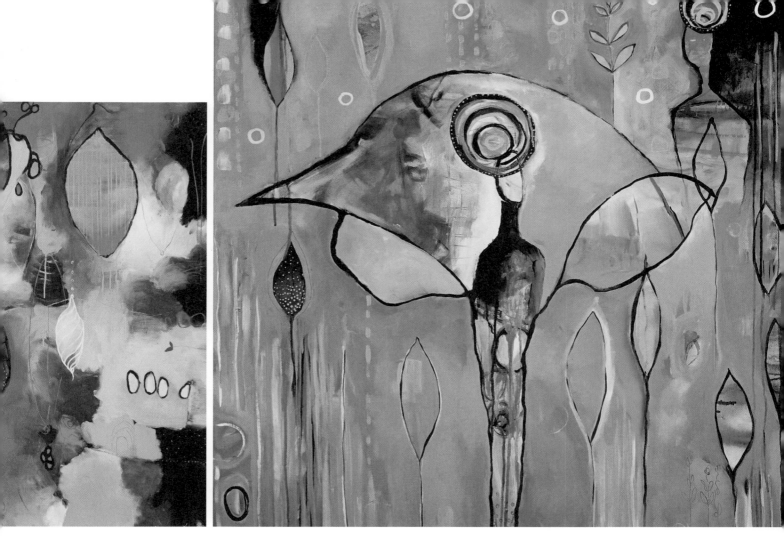

## EMERGING IMAGERY

Allowing your paintings to emerge naturally takes time and trust in the process. Be patient as you move back and forth between at least two canvases. As soon as one canvas is mostly wet, set it aside and work on your next canvas with wild abandon. Build up a few layers, moving quickly from one canvas to the next. I often work on three or four canvases at a time in this way. Incorporate as much variation as possible. Play with all of your tools and explore different ways to apply the paint. Work with the rainbow of colors. Don't worry about what it looks like. Give your critical mind a break. You are creating lots of options and laying the foundation for imagery, color palette, and composition to emerge gracefully and naturally out of the "chaos." Have I mentioned there are no mistakes?

After you have a few layers built up on your canvases, step back, do some movement, and take a look at what you've created. Begin to ask yourself, "What is working?" "What has been the most enjoyable part of this process?" Be open to noticing the emergence of unplanned shapes. Do you see a landscape, a still life, a branch, a creature? You may see only a hint of a recognizable image, but this might just be the inspiration you need. Are you especially attracted to any of these images? You may choose to define these shapes or add to them in new ways. Again, committing to a shape does not mean this is your final answer. My birds, pods, and leaves often shape-shift many times before they decide what they really want to be.

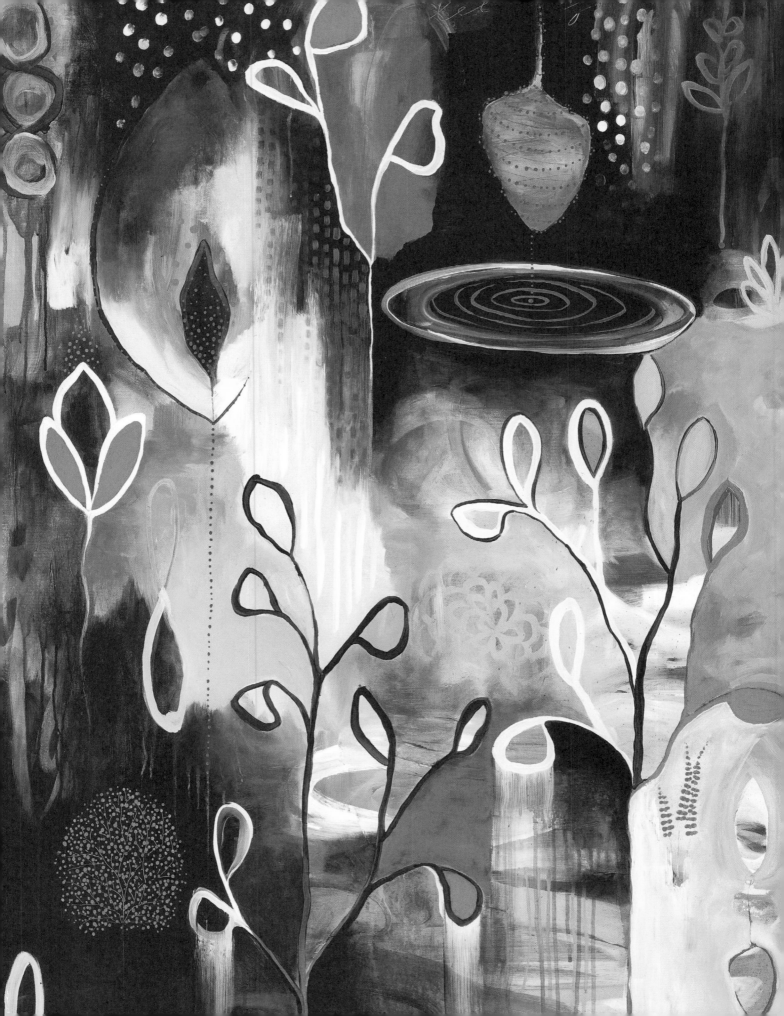

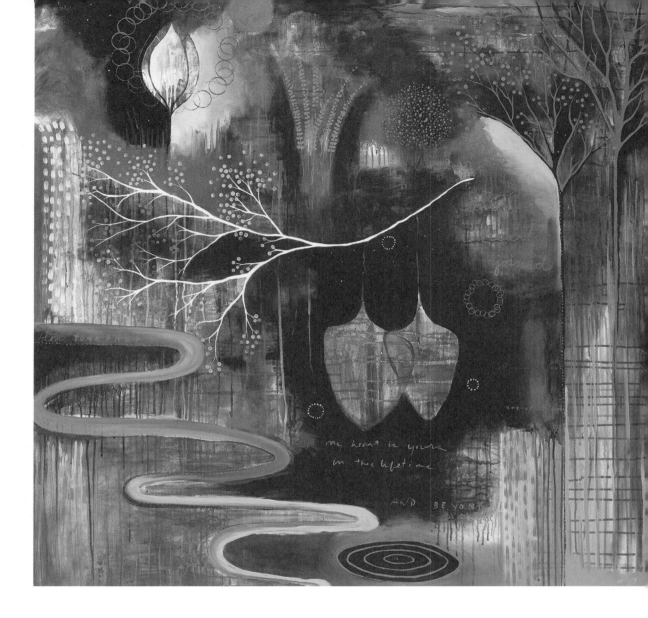

## EMERGING PALETTE

Starting with a rainbow of color options gives you the opportunity to be pleasantly surprised by new and unexpected color combinations. When you spiral out, notice which colors work well together. When spiraling back in, you might choose to use more of these colors and less of the colors that distract from the emerging palette. Remember that incorporating one, two, or three *main* colors into your palette will help to unify your painting, but allowing many colors from previous layers to peek through will add life to your finished piece.

## EMERGING COMPOSITION

In addition to imagery and color, this process also allows the composition of your paintings to emerge naturally. Composition refers to how your painting is organized on the canvas. Incorporating variation in terms of shape, line, and color will open up many compositional doors. Be open to seeing new compositions emerge even after you've worked in one distinct compositional direction for a while. A great way to discover new, interesting compositions is to turn your paintings upside down or on their sides many times before deciding on their orientation.

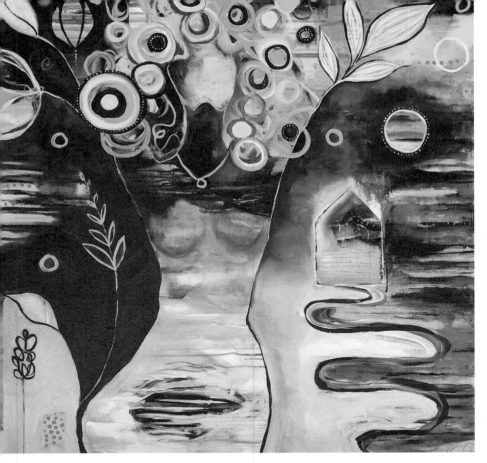

# EMBRACING NONATTACHMENT

The concept of nonattachment is a popular one in many spiritual practices— it lies at the core of contentment and deeply honors the ever-changing present moment. As a painting practice, nonattachment is the single most important principle to embrace. My students are always amazed to see how drastically my paintings change with each and every layer of paint that I add. I am able to paint in this way when I paint from a place of nonattachment, acceptance, and trust in the unknown. From experience, I've learned that the more I change my path along the way in terms of color and composition, the more interesting my paintings become. This understanding makes it easy to stay unattached. Remember, this is not a linear process. It is more like a dance— fluid, ever-changing, and rooted in the present moment.

Remember that being nonattached is different from being detached. *Detachment* would suggest that you simply do not care about what you are doing. Practicing *nonattachment*, however, helps you avoid hanging on too tight to your preconceived ideas about what is right and wrong and opens you up to a place of infinite possibilities.

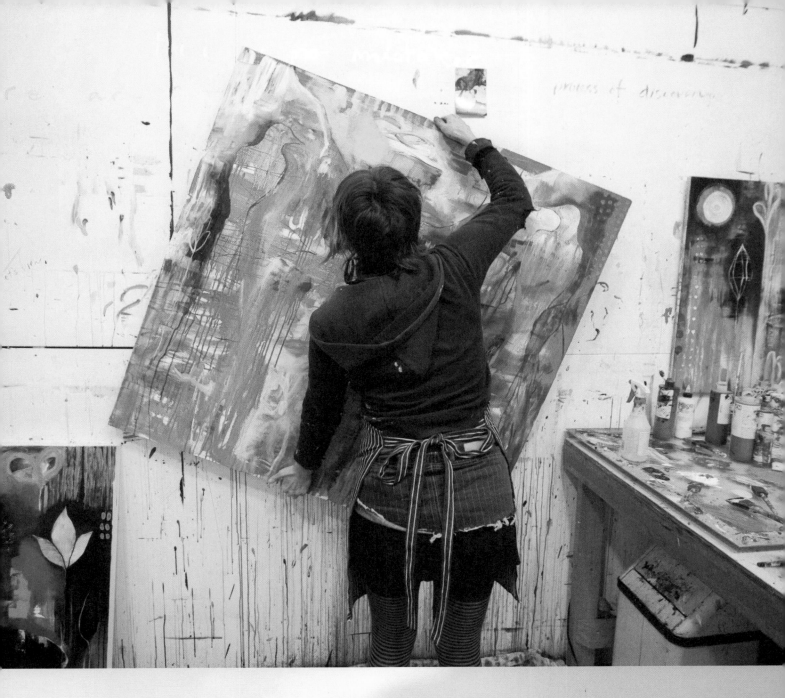

## BE BRAVE CHALLENGE: TURN, TURN, TURN

As you work on a new painting, commit to rotating your canvas ninety degrees to the right every fifteen minutes...*especially* if you don't want to. You might want to set a timer to remind you that it's time to turn your canvas. With each new turn, step back and see what is emerging. For this exercise, challenge yourself by adding new imagery with each turn. Allow your images to morph and change as you reorient the canvas. How does this feel? How does it look?

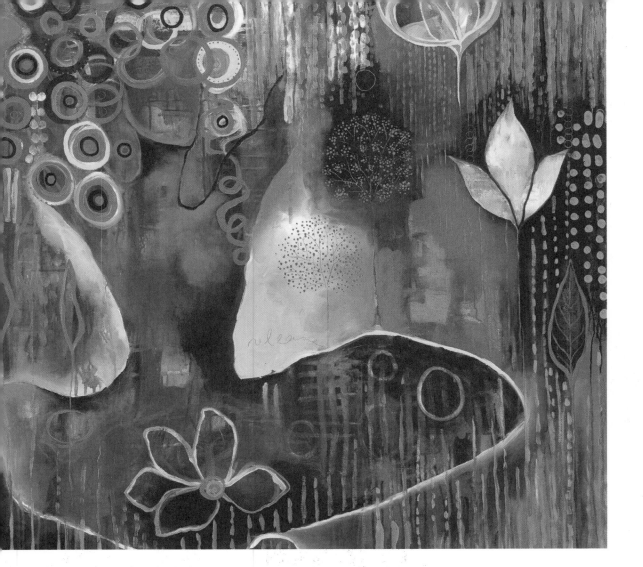

## TRUSTING YOURSELF

As you build up layers, remember a back-and-forth conversation is happening between letting go and adding in. This is all about improvisation and following your instincts. Sometimes you may need to quiet down busy areas to create harmonious, more simplified space in your composition. Other times, you might choose to cover up areas to bring new and varied marks to life. There is a constant flow between adding and removing; both actions are important, and both actions lead to more options.

Inevitably you will be drawn to certain parts of your painting. You can choose to save these areas (for now) by not painting over them, or you can also choose to let go of what you *like* to make room for areas you *love*. Be flexible with your approach. Be brave. It's only a painting and you are learning a new way. You are the person behind the brush, so anything you've created, you can likely create again. Abundant lessons in letting go are learned by working in this way, and you will find that nonattachment is a very powerful force when fully embraced. You always have more magic up your sleeve, so let go. Trust yourself. You know what to do.

## BE BRAVE CHALLENGE: CH-CH-CH-CHANGES

To practice nonattachment in your painting process, work on two new
24" x 24" (61 x 61 cm) canvases or paper. Paint for fifteen minutes on each
surface, switching back and forth between them to allow for drying time.
It will be helpful to set a timer so you don't have to think about time. After
each fifteen-minute interval, switch surfaces and challenge yourself to cover
up three-quarters of what you've previously painted on that surface. Keep
working like this for two hours to build up four layers on each surface.
Incorporate the lessons you learn here into your larger paintings (and into
your life!).

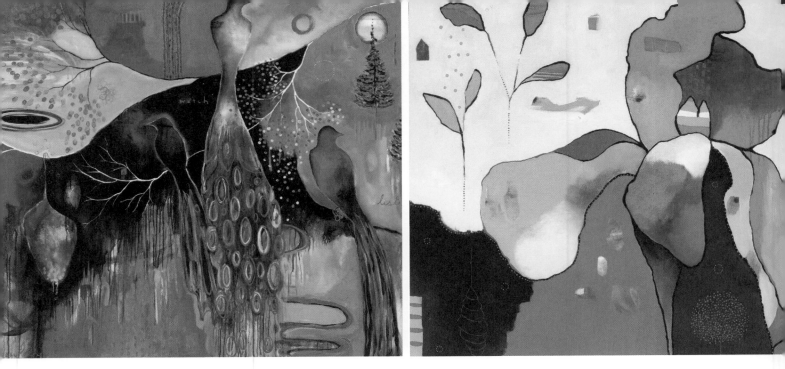

# BLOOMING TRUE AND FINDING YOUR AUTHENTIC VOICE

What does it mean to "bloom true"? For me, it starts with listening to my heart and noticing what is calling my soul into action. This does not come from my logical mind. It comes from a deeper place of knowing that is very personal and unique to me. By allowing my true voice and process to be seen in my paintings, I am giving of myself with uncompromising honesty. Remember, only you can paint like you. Express your unique flair by showing your brushstrokes, incorporating imagery that is meaningful to you, and allowing your emotions to be *felt* in your paintings. Don't hold back. Create with a sense of "going for it." Surprise yourself by following your wildest impulses and let your own voice be heard.

## A NOTE ON "BORROWING" A STYLE

There is nothing wrong and plenty to be learned from looking at other people's work and finding inspiration there; however, doing so has the potential to draw you away from your own voice. Notice when your creative expression feels forced, difficult, contrived, or simply not your own. Listen closely.

Recognize what feels authentic (or not) in all aspects of life. This recognition will strengthen your ability to come back to yourself, true and whole.

## CONNECT: I LOVE ...

Recognizing what's important to you is a powerful way to stay firmly planted on your unique path and to reveal imagery that is meaningful to you. In your journal, start a sentence with "I love …." In a free-form, intuitive fashion, scrawl out a list of things you love, from your smallest loves to whatever fills your heart the most. Start your next sentence with "I collect …." This can include things you collect, thoughts you collect, memories you collect, and so forth. Next, start a sentence with "I am inspired by …." Inspiration comes in many forms, so open your mind to these possibilities. Finish this exercise with a list of things you are grateful for. Post your words where you will see them and refer back to them when you need a bit of inspiration.

## CONNECT: YOUR INSPIRING LIFE

With increasingly busy lives, it's easy to race through life unaware of our surroundings. Give yourself the gift of slowing down to truly see your world with a fresh perspective. Even what appears to be mundane—the objects in your closet, the view from your kitchen window, the bugs in your garden—might end up being the very subject matter you've been searching for. Using a sketchbook and a pen, go on a little journey into your everyday life. Start in your home. Look around and notice what areas or objects are calling you. Follow your intuition and go in for a closer look. After a minute of observing, loosely sketch these objects. Don't worry about what your drawings look like. Add as many or as few details as you wish. When you feel complete with one object or scene, move on to the next. Allow your journey to take you outside and around your neighborhood. Follow your intuition and start to see your world with new eyes.

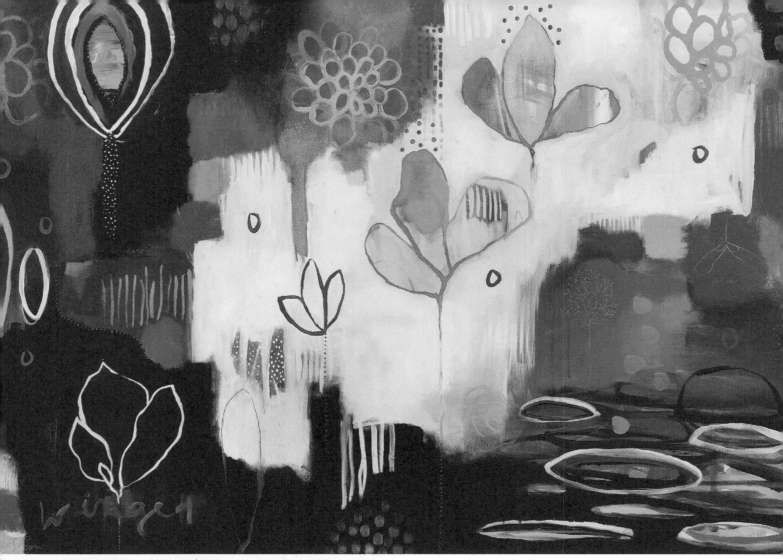

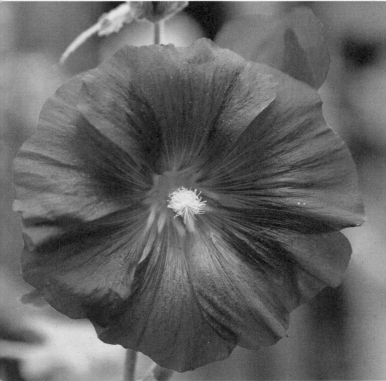

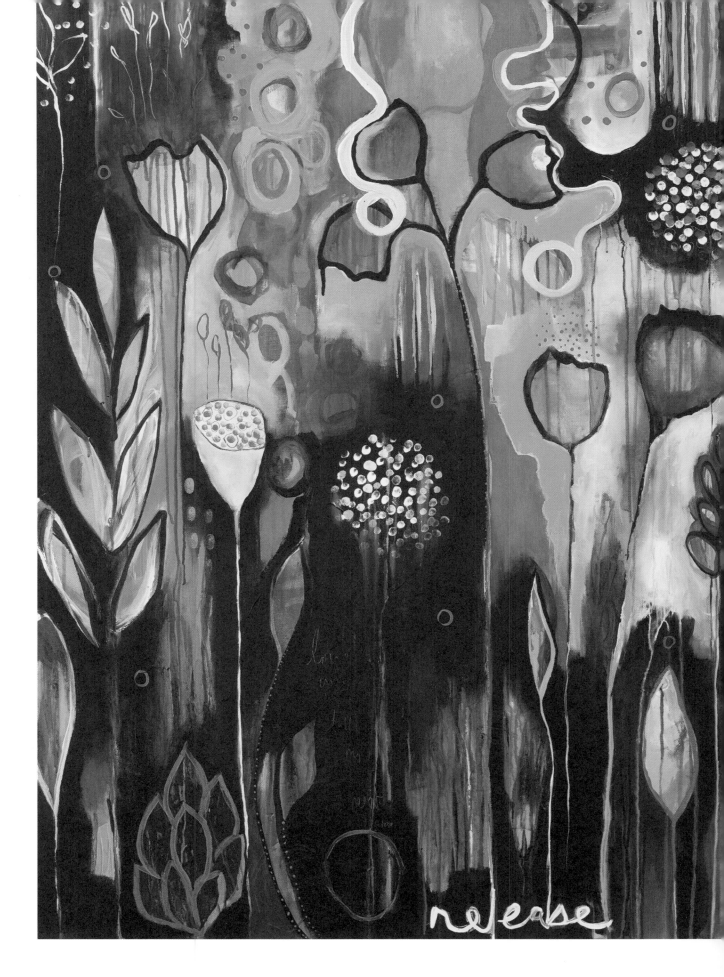

## THE POWER OF WORDS

Incorporating written words into your paintings can be a powerful way to express your voice and add new context to your work. But be aware that words can also be distracting if used in a nonauthentic way. Notice if certain words arise naturally in your mind as you work. If you choose, allow these words to spill forth into your painting. They can always be covered up, partially or fully, if they don't seem to belong after more layers are added. If you premeditate on using a word before you've started your painting, you run the risk of your words seeming contrived. ask yourself whether your words feel forced, or whether they are a natural extension of your process?

Sometimes song lyrics or snippets from conversations make their way into my paintings, but more often words pop into my mind out of thin air. This is how the title for my workshops "Bloom True" came to be. While deeply absorbed in painting, I suddenly found myself scrawling those words onto my canvas … like a simple gift from the universe. Give thanks when this kind of magic happens!

# BRINGING IT TOGETHER AND KNOWING WHEN TO STOP

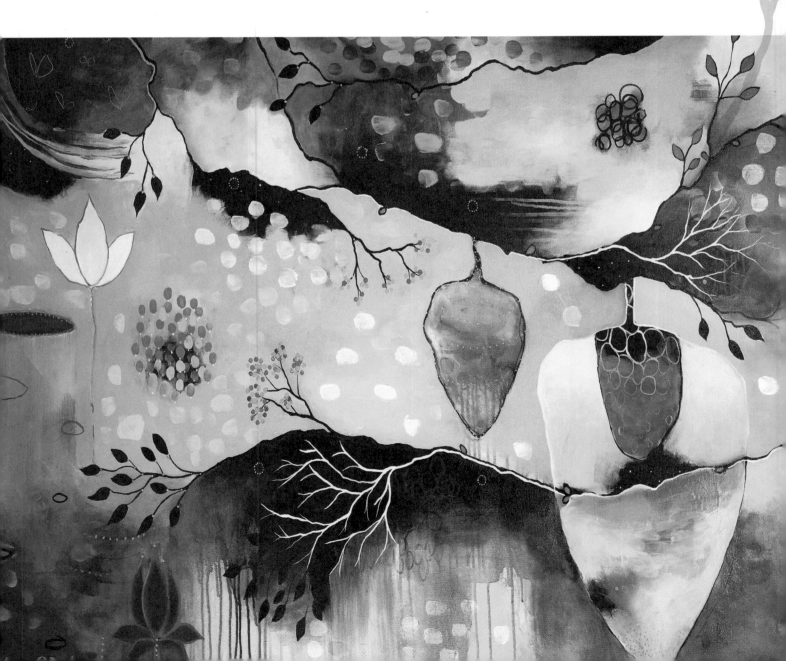

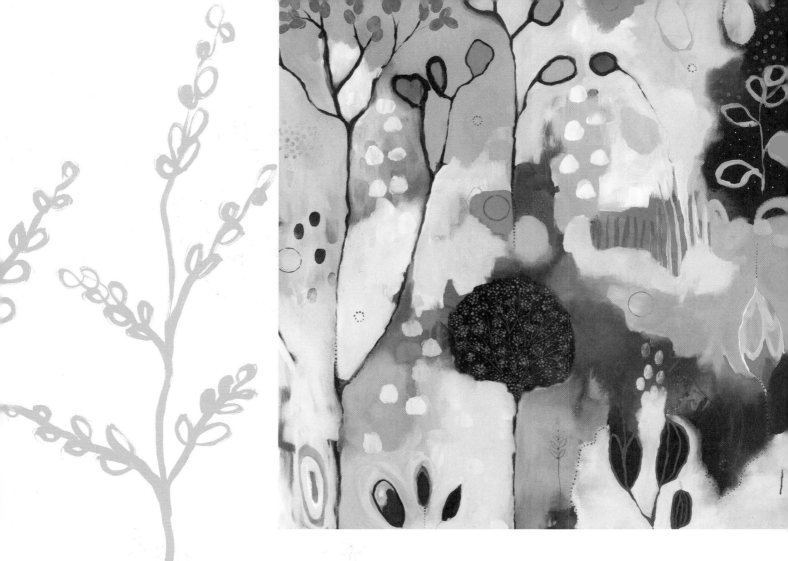

There are an infinite number of ways to bring your paintings together in a cohesive way. For example, threading one or two of the same colors throughout your painting is a great way to unify your palette. Placing similar marks or shapes throughout the composition is another effective way to tie different areas of your painting together. You can also add some fine detail with a smaller brush to give your painting a more finished look. Finally, doing something bold in the last layers of your painting—something that will stand out and give it that finishing touch—is a great way to make a lasting impression.

I am often asked the question "How do you know when your paintings are complete?" This is obviously a very personal process, and it's different for everyone. For me, the final layers require me to spend more time spiraling out to gain perspective on my work. Sometimes I take notes on the changes I'd like to make as I sit across the room from my paintings. These notes guide me as I spiral back into the finishing layers. Eventually, as I'm sitting back, I feel less of an urge to make changes. The painting is coming to a peaceful place at this point. When I can sit and gaze at the painting for long length of time, it is complete … at least for today!

## TAKING STOCK

To help you know when to stop, you might want to ask yourself the following questions as you sit back and look at your painting.

1. Are the colors harmonious and interesting?
2. Is there a primary color scheme?
3. Is there a broad range of values (lights and darks)?
4. Do your lines have character?
5. Are there variations in your marks?
6. Is your composition interesting and unique?
7. Do your eyes move around the canvas or get stuck in one spot?
8. Have you incorporated unifying elements?
9. Is there anything that looks out of place or unfinished?
10. Have you built up a variety of paint quality and textures?
11. Is there anything you want to add or change?
12. Have you been bold?
13. Can you see your authentic voice?
14. Are you happy with how it looks?

Remember that how you feel today may very well change tomorrow. Keep sitting back and asking these questions over and over for the course of a few days. Most likely, your intuition will tell you when your painting is truly done.

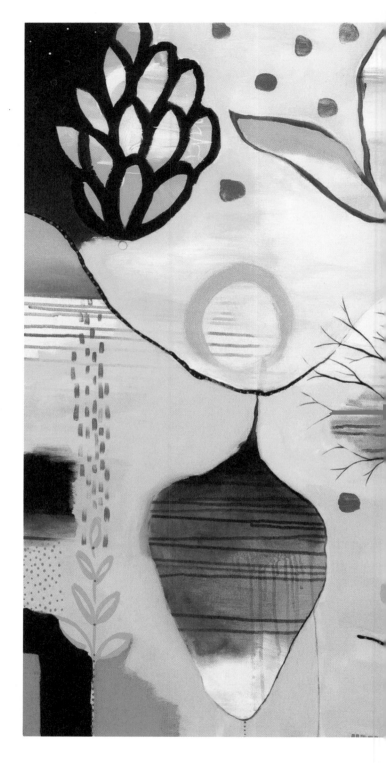

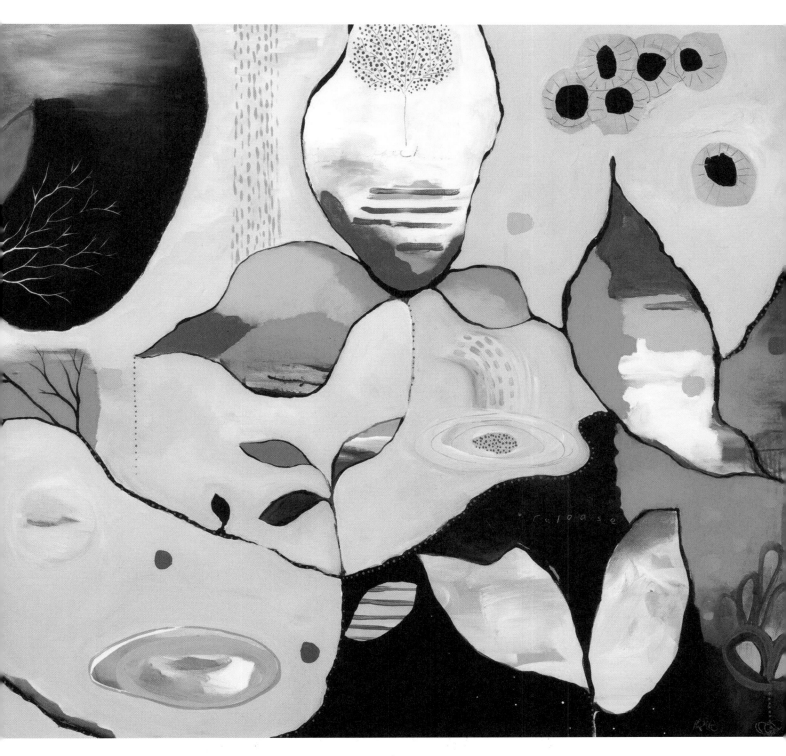

"Overcome the notion that you must be regular.

It robs you of the chance to be extraordinary." —UTA HAGEN

# ONE PAINTING, START TO FINISH

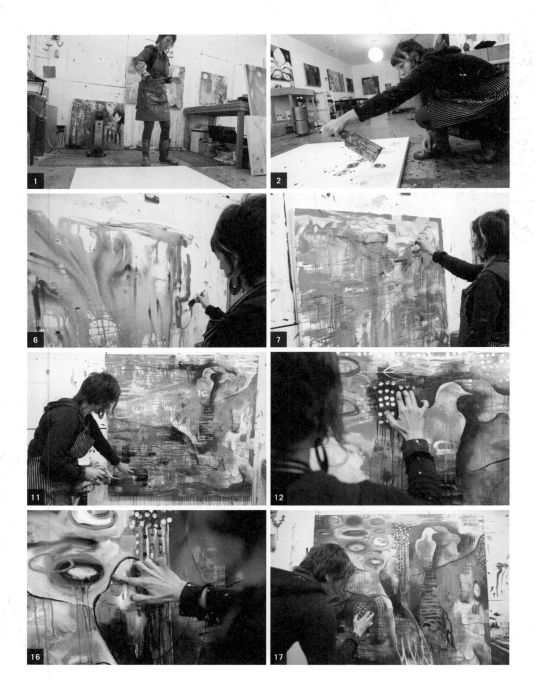

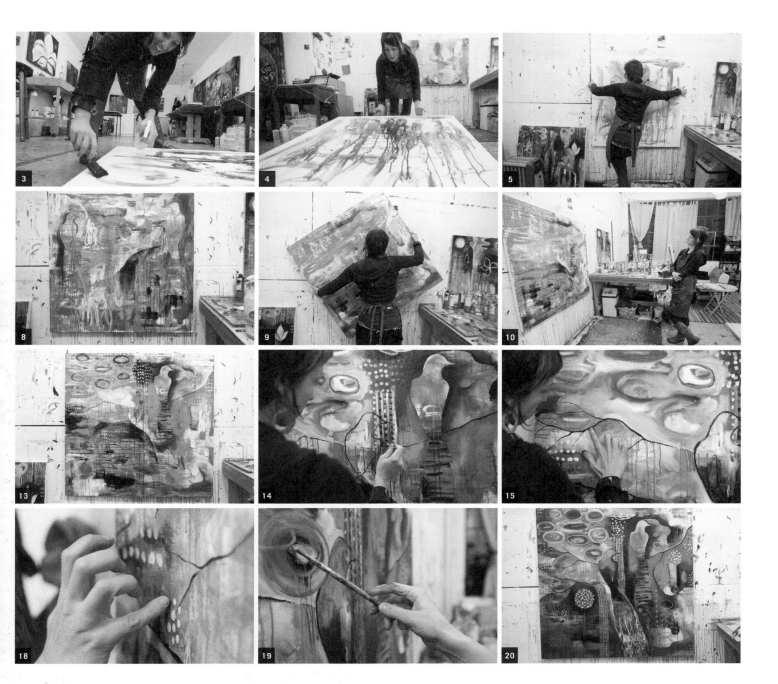

# LIVING A CREATIVE LIFE AND STAYING INSPIRED

In 1999, I completed a yoga teacher training program. I'll never forget my instructor's final words. He stated with clarity and confidence that the most important factor in staying on our true path is to place ourselves firmly within an environment that supports the life we want to live. By seeking out people and places that inspire and support us, the road to personal fulfillment becomes smooth and direct.

I've carried these words of wisdom with me for years, as I've consciously chosen to surround myself with creative, loving, and adventurous people along the way. Understanding how important it is for transformation, I gravitate toward experiences and people that will push my growing edge. When fear or frustration arise, I take a good look at where these voices are coming from and seek guidance from my wise friends and family. I also rely heavily on my intuition and remind myself often to cultivate a sense of gratitude. When we are full of gratitude, there is no room for fear.

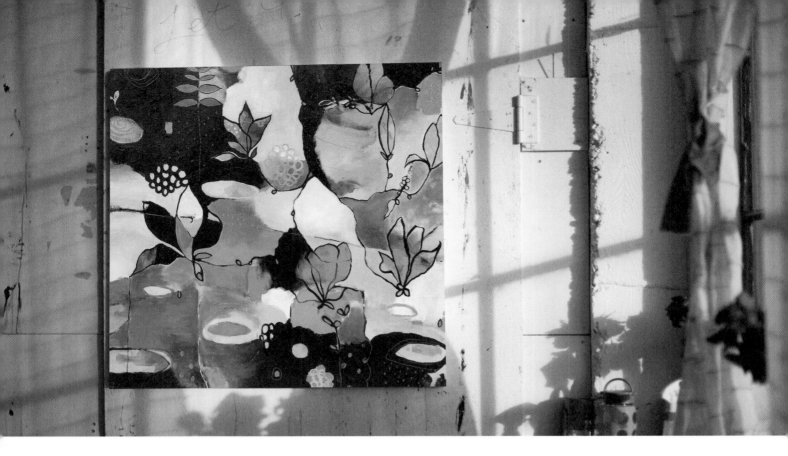

"Our deepest fear is not that we are inadequate. Our deepest fear is that we are powerful beyond measure. It is our light, not our darkness that most frightens us. We ask ourselves, Who am I to be brilliant, gorgeous, talented, fabulous? Actually, who are you not to be? Your playing small does not serve the world.

There is nothing enlightened about shrinking so that other people won't feel insecure around you. We are all meant to shine, as children do. We were born to make manifest the glory of God that is within us. It's not just in some of us; it's in everyone. And as we let our own light shine, we unconsciously give other people permission to do the same. As we are liberated from our own fear, our presence automatically liberates others." —MARIANNE WILLIAMSON

## A METAPHOR FOR LIFE

You have probably noticed by now that my approach to painting can easily be interpreted as a metaphor for life. It's true! The lessons I learn over and over again throughout my artistic process directly influence the way I choose to create my life. I understand how the power of my stories can influence what I'm capable of doing. I notice how the improvisational nature of my process strengthens my intuition every day. Lessons in nonattachment show me the freedom that comes when I let go of grasping and controlling. Staying playful as I paint reminds me of the joy I feel when I take things a little less seriously, and working bravely with what's working just makes life easier. Most important, I am able to see my life as a big, blank canvas, ready and waiting to be created however I choose to create it. The more I listen to my heart and follow my intuition, the more effortlessly life unfolds.

## TEAMWORK MAKES THE DREAM WORK

I also understand that I am not alone on this journey, nor do I want to be. Daily, I choose to operate from a place of "we" rather than "me." I glean much of my inspiration by surrounding myself with people who are following their bliss and living their dream. I choose to live in a community of artists, dreamers, and healers, and I collaborate with them often. From this place of co-creation, access to compassion, generosity, and shared wisdom is easy. Rather than feeling jealous, I experience deep joy when I see other people rising up and shining their light. When one of us succeeds, we all succeed. It is my greatest desire to see this world wake up to a new, sustainable way of living, one that celebrates diversity, honors creative expression, and encourages radical self-acceptance. I know I am not alone with this dream. I also know this kind of world is possible as more and more people tune in to their intuition, step bravely onto their true path, and watch as their empowered creative life unfolds. Remember: Your paintings want to be created. You hold the tools in your hands to manifest this vision. It's waiting to happen. Let it.

# ABOUT THE AUTHOR

FLORA BOWLEY is an internationally celebrated painter, teacher, author, and inspirationalist. Her vibrant paintings can be found in numerous galleries, on album covers, and in public spaces around the world, as well as on a variety of unique products made in collaboration with Papaya Art. Flora combines eighteen years of professional painting experience with her background as a yoga instructor and massage therapist to infuse her teaching and painting style with a deep connection to body, mind, and spirit. By honoring intuition and celebrating the present moment, Flora encourages her students to overcome fear and welcome joyful, spontaneous expression back into their creative process. Her transformational approach to painting (and living) has inspired thousands of people to "let go, be bold, and unfold." Flora splits her time between painting, teaching, and traveling in colorful locations around the world and living among a community of artists in Portland, Oregon. To take a workshop or an online course, visit www.braveintuitiveyou.com. To discover more of Flora's artwork, visit www.florabowley.com.

## ABOUT THE PHOTOGRAPHER

TARA MORRIS is a happy and grateful photographer living and working in Boston. She is the proud owner of two successful photography companies. Hitched Studios is for people in love on their wedding day and T.Spoon Photography is for "smalls" and their parents in their everyday love fest. Learn more about her work at www.tspoonphotography.com and www.hitchedstudios.com.

# ACKNOWLEDGMENTS

This book was written in five countries, in a multitude of cafés, and with the help, support, and inspiration of many people. First and foremost, I thank my students around the globe for joining me on this ongoing journey of self-discovery and creative unfolding. With deep gratitude, I acknowledge my parents and sister for instilling in me a love for travel, art, and community and for accepting all my wild adventures along the way. To Tara Morris, for our many years of friendship and for capturing my artistic process on camera so expertly and lovingly. To Stephen Funk for documenting my paintings with such care. To Cvita Mamic for all the soul reflection, artistic camaraderie, and encouragement to look even deeper. To Corrie Peterson, Jen Girarda, and Stephanie Hurley for their savvy way with words. To Mike Murnane for the support, travel companionship, and reminders to laugh, play and meditate often. To Anahata and Gina Katkin at Papaya Art for their vision and belief in my work. To Kelly Rae Roberts for all the inspiring chats and helpful insights. To Elizabeth McCrellish for believing in my teaching abilities before I did. To all my galleries, hosts, and patrons around the world for their ongoing generosity and support. To Mary Ann Hall, Betsy Gammons, and Quarry Books for planting the seed and crafting this vision into reality. To my beloved Portland family for cheering me on, dancing with me, and encouraging me to spread my wings daily. And, last but not least, to all the artists, poets, teachers, healers, and visionaries who bravely listen to their own hearts and inspire me to do the same.